GUCCI

#GucciBlondie

Fall 2022
The 70th Anniversary Issue

Words & Pictures

Front cover:
Design by A2/SW/HK, London

Opposite:
Imogen Cunningham, *Ruth Asawa and Her Children*, 1957, from *Aperture*, **Winter 1964**
Photograph © Imogen Cunningham Trust. Artwork: © Ruth Asawa Lanier, Inc./ Artists Rights Society (ARS), New York

Subscribe to *Aperture* and visit archive.aperture.org for every issue since 1952.

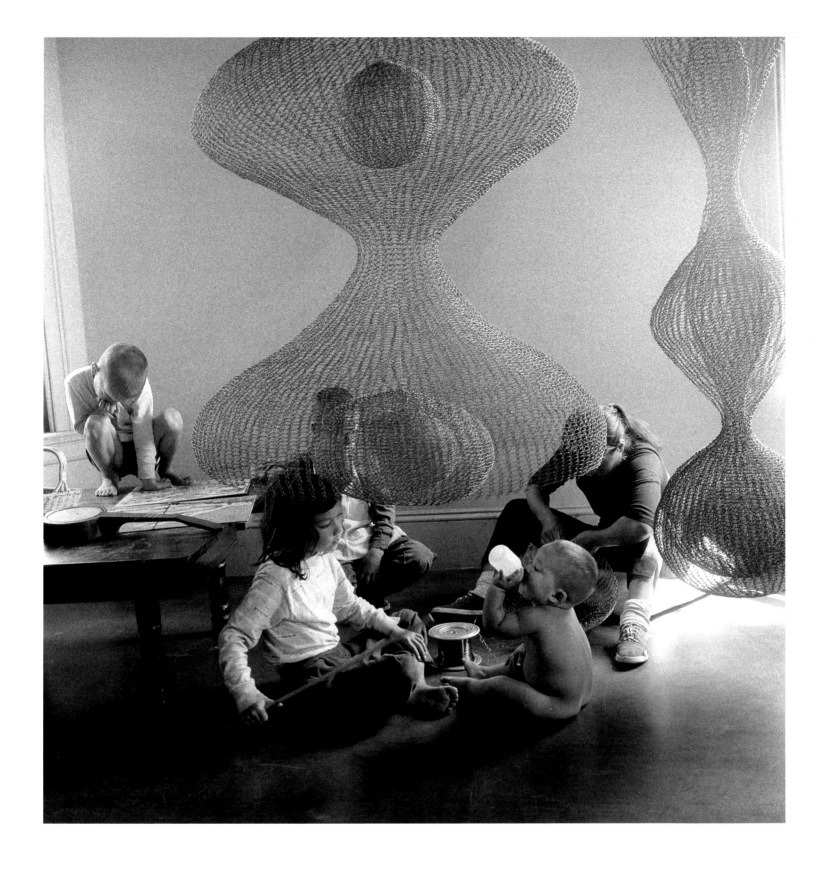

Aperture, a not-for-profit foundation, connects the photo community and its audiences with the most inspiring work, the sharpest ideas, and with each other—in print, in person, and online.

Aperture (ISSN 0003-6420) is published quarterly, in spring, summer, fall, and winter, at 548 West 28th Street, 4th Floor, New York, N.Y. 10001. In the United States, a one-year subscription (four issues) is $75; a two-year subscription (eight issues) is $124. In Canada, a one-year subscription is $95. All other international subscriptions are $105 per year. Visit aperture.org to subscribe. Single copies may be purchased at $24.95 for most issues. Subscribe to the *Aperture Digital Archive* at aperture.org/archive. Periodicals postage paid at New York and additional offices. Postmaster: Send address changes to *Aperture*, P.O. Box 3000, Denville, N.J. 07834. Address queries regarding subscriptions, renewals, or gifts to: *Aperture* Subscription Service, 866-457-4603 (U.S. and Canada), or email custsvc_aperture@fulcoinc.com.

Newsstand distribution in the U.S. is handled by CMG. For international distribution, contact Central Books, centralbooks.com. Other inquiries, email orders@aperture.org or call 212-505-5555.

Become a Member of Aperture to take your interest in and knowledge of photography further. With an annual tax-deductible gift of $250, membership includes a complimentary subscription to *Aperture* magazine, discounts on Aperture's award-winning publications, a special limited-edition gift, and more. To join, visit aperture.org/join, or contact membership@aperture.org.

Credits for "Curriculum," pp. 26–27: Bronx: Courtesy the artist; E. Jane: Courtesy the artist; *Legendary*: HBO Max/Warner Media; Hujar: © The Peter Hujar Archive/Artists Rights Society (ARS), New York; Atget: © The Museum of Modern Art/SCALA/Art Resource, NY

Credits for photographs from issues of *Aperture* in Hank Willis Thomas's portfolio, pp. 134–141: Brathwaite: courtesy the Kwame Brathwaite Archive; Ewald & Gottesman, Swindells, Meyerowitz, Sethi, Voit, and Cox: Courtesy the artists

Photography of *Aperture* issues by Jason Mandella

Library of Congress Catalog Card No: 58-30845

ISBN 978-1-59711-526-1

Printed in Turkey by Ofset Yapimevi

OFSET
YAPIMEVİ

Support has been provided by members of *Aperture*'s Magazine Council: The Kanakia Foundation, Jon Stryker and Slobodan Randjelović, Susan and Thomas Dunn, and Michael W. Sonnenfeldt, MUUS Collection. Additional support is provided in part by the New York City Department of Cultural Affairs in partnership with the City Council.

Aperture Foundation's programs are made possible in part by the New York State Council on the Arts with the support of the Office of the Governor and the New York State Legislature.

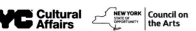

aperture

The Magazine of Photography and Ideas

Editor
Michael Famighetti

Senior Managing Editor
Brendan Embser

Assistant Editor
Varun Nayar

**Contributing Editor,
The PhotoBook Review**
Lesley A. Martin

Copy Editors
Donna Ghelerter, Chris Peterson

Production Director
Minjee Cho

Production Manager
Andrea Chlad

Press Supervisor
Ali Taptık

Art Direction, Design & Typefaces
A2/SW/HK, London

Publisher
Dana Triwush
magazine@aperture.org

Director of Brand Partnerships
Isabelle Friedrich McTwigan
212-946-7118
imctwigan@aperture.org

Advertising
Elizabeth Morina
917-691-2608
emorina@aperture.org

**Executive Director,
Aperture Foundation**
Sarah Meister

Minor White, Editor (1952–1974)

Michael E. Hoffman, Publisher and Executive Director (1964–2001)

aperture.org

Alexey Vasilyev
from the photo series „Sakhawood"
Kodak Pro Endura | 27.5 x 19,7 in. | Original Photo Print under Acrylic Glass | Floater Frame „Basel", Black Oak

Bringing photography to completion
When an image becomes visible as a print, it transforms from an abstract idea into reality. For WhiteWall, that means that a picture is only complete once it is hanging on the wall. We achieve perfection through craftsmanship, innovation, and use of the very best materials. Our award-winning gallery quality is always accessible to photo enthusiasts both online and in our stores.

The exhibition is part of the Triennial of Photography Hamburg and will be displayed in the Hall for Contemporary Art from May 20 to September 28.

WHITE WALL

Diane Arbus
Documents

A groundbreaking publication
charting the reception of
the unrivaled photographer's work.

David Zwirner Books **FRÆNKEL**

Published by Fraenkel Gallery and David Zwirner Books.
Now available wherever books are sold.

Agenda
Exhibitions to See

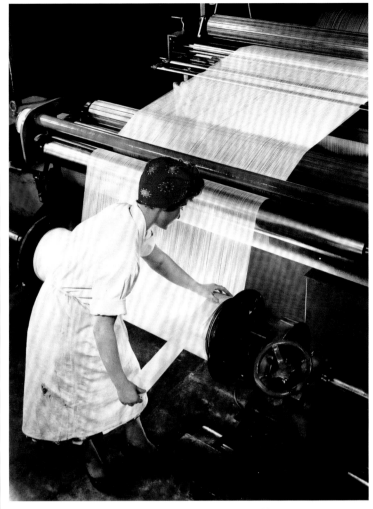

Maurice Broomfield

Maurice Broomfield chronicled with a painterly eye a time of great transition in postwar Britain. Working as the country's leading industrial photographer in the 1950s and 1960s, often on commission, he pictured factory workers with a focus on the dramatic and surreal. In *Maurice Broomfield: Industrial Sublime*, at the Victoria and Albert Museum, in London, these vibrant and carefully composed images express the photographer's optimism toward British industrial progress in the wake of war. Broomfield grew up in the country's heartland, near Derby, and was influenced by both his time working at a Rolls-Royce factory in the early 1930s and his interest in graphic design and painting. Many of the sites in his images have since vanished or been folded into large global corporations. Yet today, as the V&A curator Martin Barnes notes, Broomfield's archive is "historically illustrative of myriad industries, a resource for the study of material culture and emblematic of human ingenuity more generally."

Maurice Broomfield: Industrial Sublime **at the Victoria and Albert Museum, London, through November 6, 2022**

Maurice Broomfield, *Preparing a Warp from Nylon Yarn*, British Nylon Spinners, Pontypool, Wales, 1964
© Estate of Maurice Broomfield

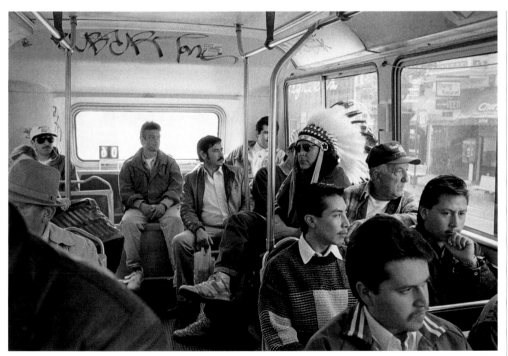

Zig Jackson, *Indian Man on the Bus, Mission District, San Francisco, California*, 1994
© the artist and courtesy the Amon Carter Museum of American Art, Fort Worth, Texas

Speaking with Light

As an art student in San Francisco in the 1990s, Zig Jackson began photographing himself around the city wearing a feathered headdress. Jackson is of Mandan, Hidatsa, and Arikara descent, and he grew up on the Fort Berthold Indian Reservation in North Dakota. With sardonic sartorial wit— fly high-tops, cuffed denims, and imperious sunglasses—his series *Indian Man in San Francisco* (1994) "tells an extended joke about cultural and social stereotype," says the curator John Rohrbach, who has organized, together with the artist Will Wilson, *Speaking with Light: Contemporary Indigenous Photography* at the Amon Carter Museum of American Art, a major survey that recognizes three decades of image making by more than thirty Indigenous artists, including Jackson, Meryl McMaster, Kimowan Metchewais, Wendy Red Star, and Hulleah Tsinhnahjinnie. Even as Jackson rides public transit dressed, Rorhbach notes, as a "Hollywood evocation of a Plains Indian chief," he nonetheless inserts himself with authority, presenting "another reminder of our cultural diversity."

Speaking with Light: Contemporary Indigenous Photography **at the Amon Carter Museum of American Art, Fort Worth, Texas, October 30, 2022– January 22, 2023**

Martine Syms, *Misdirected Kiss*, 2016
© the artist and courtesy Bridget Donahue, New York

Martine Syms

The opening set piece of Martine Syms's first feature film, *The African Desperate* (2022), takes place on the last day of graduate school for a young artist named Palace, who is finishing her MFA at a college in the Hudson Valley very much like Bard. Palace, a Black woman from Chicago, faces a critique with several white professors, who talk more than listen, expound on arcane theories, and toss off arrogant microaggressions. The moment is played for laughs, but when Palace breaks down in tears afterward—and later spirals into a delirious night of drugs and dancing—Syms implies that it's all too real. Syms herself completed her MFA at Bard, and *The African Desperate*, in a twist appropriate to the film's satirical wisdom, will be screened as part of *Grio College*, Syms's solo exhibition at Bard's Hessel Museum of Art, which also features platform-spanning videos, photographs, installations, and drawings that together interrogate ideas about Black femininity and gesture.

Martine Syms: Grio College **at the Hessel Museum of Art, Annendale-on-Hudson, New York, through November 27, 2022**

Sibylle Bergemann

Writing in 1973, the East Berlin–born Sibylle Bergemann described her approach to photography as "an attitude to people and their relationships, to things and their connections, that is perceived and communicated sensually." In a career that spanned more than four decades in her home city and beyond, Bergemann captured the nuances of everyday life during and after the German Democratic Republic with sensitivity and skill, making images ranging from her early social-realist reportage to her renowned fashion work and portraits. *Sibylle Bergemann. Town and Country and Dogs. Photographs 1966–2010*, a retrospective at the Berlinische Galerie, traces the evolution of Bergemann's artistic and personal vision, presenting more than two hundred photographs taken around the world, including in New York, Moscow, and Paris, many displayed for the first time. "Whether for fashion or portrait photography, or for reportage, whether unbidden or on commission," says the curator Katia Reich, "Bergemann followed her gift for translating essences sensed from observations into photographs."

Sibylle Bergemann. Town and Country and Dogs. Photographs 1966–2010 **at the Berlinische Galerie, Berlin, through October 10, 2022**

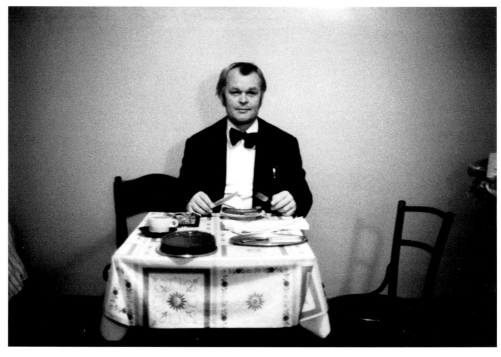

Sibylle Bergemann, Clärchens Ballhaus, Berlin, 1976
© Estate of Sibylle Bergemann/OSTKREUZ and courtesy Loock Galerie, Berlin

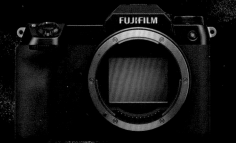

MORE THAN FULL FRAME™
FUJIFILM GFX 50sII

HIGH RESOLUTION	X-PROCESSOR 4	ISO	IN-BODY
51.4 MEGAPIXEL	**QUAD-CORE**	**100–12,800**	**6.5-STOPS**
BSI CMOS SENSOR	IMAGING ENGINE	SENSITIVITY RANGE	STABILIZATION

A modern notebook since 1934

Made in France

Collecting

Mikki Ferrill's photographs expand a museum's collection—and representations of Black joy.
Casey Quackenbush

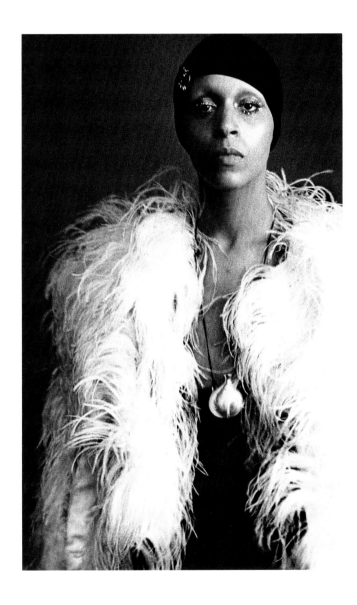

By day, the Garage, on the South Side of Chicago, functioned as its name would suggest. But on Sundays, the venue transformed into a pop-up dance club, where a predominantly Black crowd would boogie to jazz and R&B from early afternoon through sunset. Right in the midst of the party, crouching on the dance floor with a camera, was Valeria "Mikki" Ferrill, a Chicago-born photographer who spent the 1970s documenting the Garage and whose work has recently been acquired by the Philadelphia Museum of Art (PMA).

Born in 1937, Ferrill was drawn to various subcultures over the course of her career: the gay scene in San Francisco, African American cowboys, the Nation of Islam. But her most notable images are from *The Garage* (1970–80), a series that exudes the joy, freedom, and romance of a community to which Ferrill belonged.

"It was like my spiritual release being there," Ferrill told me. "Just being lost in the music, you didn't think of anything but what was happening and what you were experiencing."

Peter Barberie, the PMA's curator of photographs, knew Ferrill's work through the Art Institute of Chicago's 2018 exhibition *Never a Lovely So Real: Photography and Film in Chicago, 1950–1980*. Barberie then came across it again in an exhibition at the Keith de Lellis Gallery, New York. In 2021, he acquired five prints by Ferrill for the museum: three party scenes from the Garage, a giddy street photograph, and a portrait of a person in drag, striking a pose in a feather boa and staring intently into the camera. "They show people making their own community and their own happiness," Barberie said recently of the photographs, "as if they're saying, 'Whatever is wrong, whatever is out of control, we can still have a dance party on a Sunday at the Garage.'"

The PMA's acquisition of Ferrill's photographs dovetails with the museum's broader expansion, along with that of many other U.S. cultural institutions, of its holdings by artists of color, especially American women in this group. It's an effort that's been underway for at least the last seven years, said Barberie, but was accelerated by the social justice movements of 2020. And it's especially important to the PMA, whose Philadelphia base is 42 percent Black. "We need Black joy in our museum," said Barberie. "We owe it to our audience to have images like this."

After studying advertising design and illustration at the School of the Art Institute of Chicago, Ferrill apprenticed for Ted Williams, a notable jazz photographer. While working as a freelance photojournalist, she began chronicling the Garage, where she became known as "the picture-taking lady." She would even paste her photographs of the parties on the Garage's walls, creating an exhibition in real time for the partygoers. "Very seldom do you get the opportunity to give back to your subjects," Ferrill said. "They adored seeing themselves on the wall."

With a Pentax and Nikon SP, Ferrill employed a relaxed, informal style that chimes with the genres of both personal subject matter and street photography. But it's Ferrill's acute sensibility that makes her photographs dance off the page and makes us rethink what that garage on the corner was really all about.

Mikki Ferrill, *Untitled*, ca. 1970
© the artist and courtesy the Philadelphia Museum of Art

Casey Quackenbush is a writer based in Brooklyn.

Opposite:
still life, New York, 2001;
this page: *August self
portrait*, 2005
All photographs courtesy
the artist; David Zwirner;
Galerie Buchholz, Berlin/
Cologne; and Maureen
Paley, London

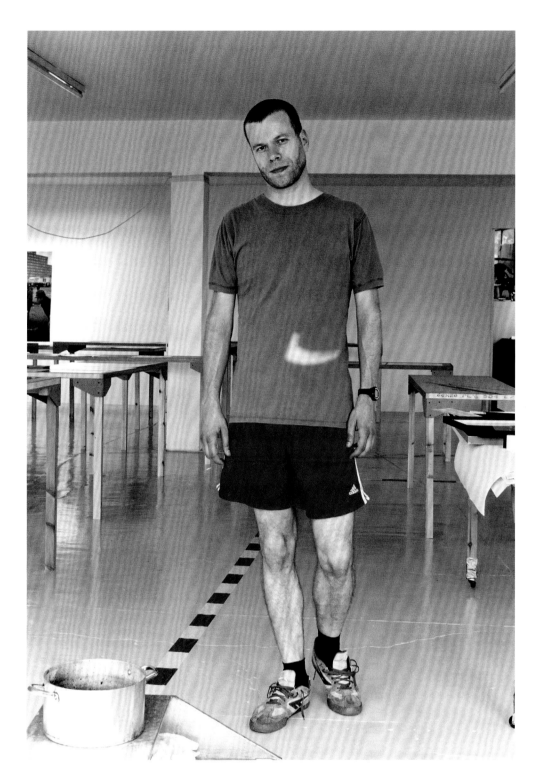

us to reflect on lived political and social realities while also making us feel safe and loved. It extends from his tender images to his decades-long commitment to activist causes such as LGBTQIA and immigrant rights. For Tillmans, photographs are no more precious than the world in which they circulate.

"Wolfgang thinks about the photographic print as akin to a body," Taylor says, "and focuses on the borders, the edges of photographs, the negative spaces, the intervals between images." The social dimension of his work exists both in these paper margins and in the dynamic spaces where these photographic bodies come together. Like a body, the show has been subject to changes—

"a living entity," as Marcoci says. If such open-endedness seems anathema to MoMA's reputation as the gatekeeper of modernism, it's also reflective of the way the museum has been changing since the rehang of its permanent collection in 2019. It could even be argued that Tillmans partly inspired the erosion of disciplinary hierarchies there. These changes made possible many close relationships, and, like Tillmans's work, they will create space for new ones.

"I want to open up an affirmative space," Tillmans told the curator Neville Wakefield in 1995. MoMA's survey is proof that in the ensuing decades he has accomplished even more. "To look without fear" perhaps means to look

without worrying about what will be reflected back at you. It's a form of viewership whose root desire is to engage. This democratic vision of photography can be seen equally in the ways Tillmans gathers text and images together and the ways that bodies commune within them. His work has room enough for us all.

Wolfgang Tillmans: To look without fear is on view at the Museum of Modern Art, New York, through January 1, 2023.

Evan Moffitt is a writer based in New York. He is the creator and host of the documentary podcast *Precious Cargo*.

mpb.com

Buy. Sell. Trade. Create.

Photography can

CHANGE

the

MPB puts cameras and lenses
into more hands, more sustainably.

**MPB. The platform to buy and
sell used photo and video kit.**

mpb.com #ChangeGear

bigger

picture.

Day Jobs

Building fences in Texas prepared Christopher Anderson for documentary work on the front lines.

Randy Kennedy

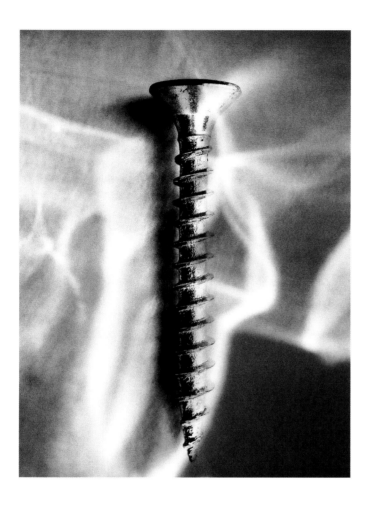

The Texas cowboy poet Red Steagall once wrote about a young cowboy who looked down his nose at the wearisome ranch job of fence building, finding it too mundane and unromantic for a real buckaroo. Consequently, he does shoddy work on a line of fence and receives a lecture from an old ranchman about the importance of doing necessary things well, for their own sake but also, maybe, for the sake of the person one might become:

> And someday you'll come ridin'
> through
> And look across this land,
> And see a fence that's laid out straight
> And know you had a hand.

The Magnum photographer Christopher Anderson—who came to prominence in 1999 for his harrowing chronicle of a doomed journey by a group of Haitian refugees attempting to travel six hundred miles to the United States in a wooden boat—grew up on the plains of West Texas and at fourteen began helping his older brother build residential fences in the summers. It was hot, arid work, and as the junior member of the team, Anderson ended up with the worst part of it: wielding a post-hole digger to pound through the hard caliche that lies just below the topsoil in drier parts of the state.

"It was a very tough job under the Texas sun, real *No Country for Old Men*

country," Anderson said in a recent call from London, where he was on location for a commercial assignment. "The caliche would eventually just chew up the post-hole diggers and your hands and your back. I also learned how to swing a hammer and, after a while, the finer points of how to make a good fence. I kept doing the work with my brother and then later by myself through high school and college—it was the way I made spending money and gas money, and it not only put me through college but also got me my first camera, a Pentax K1000."

Anderson spent many years documenting upheaval and violence in places such as Afghanistan, Iraq, and Venezuela under Hugo Chávez before moving into more personal documentary projects, along with fashion and other commercial work after the birth of his son, Atlas. Of the many odd jobs he held when he was young—mowing lawns, slicing roast beef at a Chuck Wagon restaurant ("lost part of a finger on that one"), waiting tables ("that was really the worst of them")—he says that the fence-building years, in unforeseen ways, laid considerable groundwork for the life he has made in photography.

"I don't know if it exactly prepared me for doing dangerous things early on, but it certainly showed me how to deal with discomfort and difficulty, to understand that sometimes work is just really hard, and you do what you have to do," he explains. "But the more important thing it taught me was about a certain kind of craft involved in documentary photography. I come from the predigital era. You needed to know how to expose film, and develop film, and print pictures well."

"Much is made about the art of photography," he adds, "but not enough about the artisanal aspects of it—that's what draws me to it, whether it's being in war zones or doing commercial jobs like the one I'm on right now. I show up first thing in the morning, and I work as hard as I can until the sun goes down. I always think of that great quote from Chuck Close: 'Inspiration is for amateurs. The rest of us just show up and get to work.'"

Christopher Anderson,
Artisanal still life with screw, 2022
Courtesy the artist/Magnum Photos

Randy Kennedy is the editor in chief of *Ursula* magazine, published by Hauser & Wirth.

UNDERSTANDING THE WORLD THROUGH PHOTOGRAPHY

A vivid and moving celebration of the ways that Black Americans have shaped and been shaped by photography.

"A palpable, living document not only of a formidable artist, but also of an electric era upon which the present stands."
—Mary Jane Jacob, curator and editor of Gordon Matta-Clark: A Retrospective

Fresh interpretations of Muybridge's famous motion studies through the lenses of mobility and race.

"An archivally rich and methodologically innovative study."
—Art Journal

Gold Medal for Contribution to Publishing, California Book Awards

"A fascinating and indispensable book."
—Los Angeles Times

"Analyzes landscape photography as an instrument of empire, revealing the cultural and political work done by these artists of light."
—Tom Griffiths, Professor Emeritus, Australian National University

UNIVERSITY of CALIFORNIA PRESS

www.ucpress.edu

Dispatches

Billy H.C. Kwok grapples with the events that have turned life in Hong Kong and Taiwan upside down.

Ryan Ho Kilpatrick

A deck of most-wanted playing cards lies faceup on the screen, each identifying a member of Hong Kong's prodemocracy movement rounded up by police, many still languishing in pretrial detention more than a year and a half after participating in a "seditious" by-election. In another image, sheets of stationery shop paper on which customers test pens are filled with antigovernment slogans. At the end of the day they will be removed and replaced, but for a brief moment in time this is one of the few fleeting canvases where Hong Kongers can express themselves. The photographer Billy H.C. Kwok is sharing this preview of his latest project, about

Hong Hong, an exploration of how his fellow citizens are adapting to—or escaping—a whole new political reality in which the freedoms and distinctive identity they long took for granted are rapidly being quashed.

Kwok ruffles through his growing collection of objects related to Hong Kong's recent history and produces a commemorative Barbie doll marking the city's handover to Chinese rule in 1997. She wears imperial garb from near the end of the Qing dynasty, in the early twentieth century. The disconnect between the symbol and the substance of contemporary Hong Kong speaks to its predicament: lost

and overlooked in the shadow of empires, long known to the world as a political token and financial hub yet rarely as a home to real people with their own self-perception and aspirations.

In a recent conversation, Kwok told me that the Hong Kong work is imbued with a unique note of urgency: "Today, China is taking over everything, including our ideology and our memories. I have to collect these things right now because they're moving so fast and the next day they might disappear." He calls this work "a psychological response to my birthplace, a story about Hong Kong and me." He also recognizes it as an attempt to process

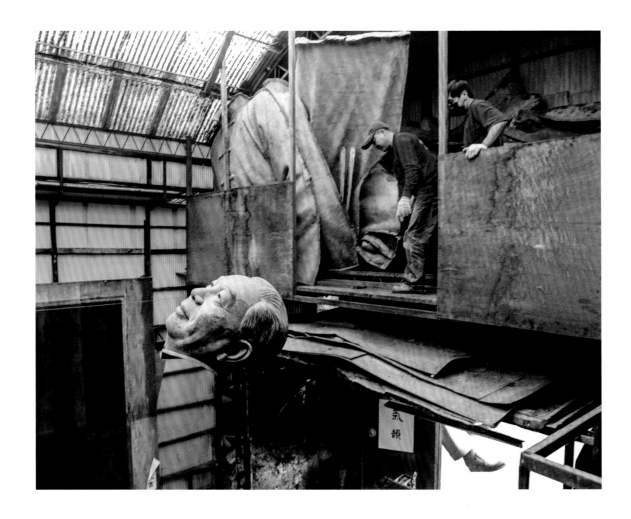

what is going on in Hong Kong in real time, to make sense of events that have turned life in the once-freewheeling city upside down.

The Hong Kong project began as an outgrowth of Kwok's previous work in Taiwan documenting the enduring legacy of the White Terror. That series, *Last Letters* (2019), unearthed the words of the thousands of political prisoners killed under martial law, from 1949 to 1987, in letters written—but never delivered— to their loved ones on the eves of their executions. Using archives and official records, Kwok tracked down the intended recipients of these letters, then captured the moment they finally got to read their loved one's words.

"They say goodbye to their unborn son or daughter," Kwok explains, "or they say sorry to their parents-in-law for not

The Hong Kong project began as an outgrowth of Kwok's previous work in Taiwan documenting the enduring legacy of the White Terror.

taking care of their daughter." He adds that "the most touching thing is not only the letters but the reactions of each family. Sometimes you see decorations in the house, and family pictures, which is worth more than just reading the letters. The trauma is real; it's not just in the past."

For Hong Kong, Kwok's hometown, that trauma is now a fact of everyday life. He started *Last Letters* in 2017, before the 2019–2020 protests that saw millions take to Hong Kong's streets, resulting in Beijing's imposition of a national security law that has ushered in a new "white terror." With the city's once-outspoken political opposition now in jail or exile, Hong Kongers are looking to Taiwan's decades of martial law for wisdom on how to survive under authoritarianism, and for hope that this, too, shall pass.

In 2019, Kwok says, many young protesters in Hong Kong also brought their own "last letters" with them to the front lines, in case they never made it home. In these, they explained to their often-disapproving families their motivations for protesting and declared their refusal to kill themselves—reflecting a widespread fear that police were killing protesters and staging the deaths as suicides. The project he began as a mirror of Taiwan's lingering generational trauma has returned as a heartrending visage of Hong Kong's ongoing ordeal.

As part of his Hong Kong series, Kwok has also been documenting the exodus of Hong Kongers since the crackdown began, following the process as they prepare to sever ties with their home and start afresh in strange new lands. Conscious of a similar wave of emigration that occurred in the lead-up to 1997 but that later saw many people return, he is curious if this time the trend will be more permanent. He is asking friends who have already made the move to send him items from or photographs of their new homes, providing him a look at how the symbols in destination countries contribute to the formation of their societies' respective ideologies.

Unlike in *Last Letters*, Kwok didn't begin with an idea of the bigger picture he was trying to portray. Nor does he have the benefit of decades of time between these events and his own work. Instead, he is "looking at a situation in the present, continuous sense," he says, progressing image by image to form a perspective out of fragments. "Because seventy years have already passed, researching Taiwan's White Terror can feel quite distant.

But what about a white terror happening right now? You have no way to step back," he states.

Kwok accepts that he will likely never be able to exhibit this series in Hong Kong due to the chilling effect of the government's ongoing restrictions. With John Lee, a hard-liner newly elevated as the territory's chief executive and who spearheaded the crackdown, this situation is unlikely to relent anytime soon. Photographers and artists have to wonder if it is even possible to work under these circumstances without subtly, unconsciously self-censoring. "The most challenging thing" about documenting Hong Kong's white terror, Kwok says, "is that you're in it."

Ryan Ho Kilpatrick is a writer based in Taipei.

Fall 2022 Books

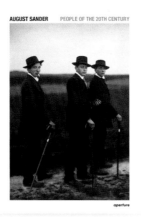

August Sander: People of the 20th Century
Photographs by August Sander
Edited by Die Photographische
Sammlung/SK Stiftung Kultur, Cologne
Texts by Gabriele Conrath-Scholl and
Susanne Lange
August 2022
US $150.00 / UK £110.00

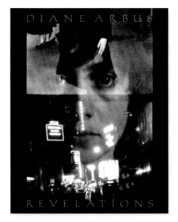

Diane Arbus: Revelations
Photographs by Diane Arbus
Texts by Doon Arbus, Sarah H. Meister, Sandra
S. Phillips, Jeff L. Rosenheim, Neil Selkirk, and
Elisabeth Sussman
September 2022
US $80.00 / UK £65.00

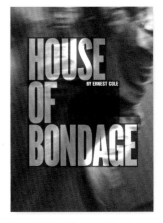

Ernest Cole: House of Bondage
Photographs and texts by Ernest Cole
Preface by Mongane Wally Serote
Texts by Oluremi C. Onabanjo and
James Sanders
November 2022
US $65.00 / UK £50.00

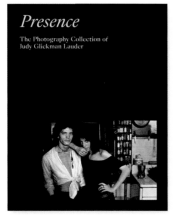

Presence: The Photography Collection of Judy Glickman Lauder
Texts by Mark Bessire, Anjuli Lebowitz, Judy
Glickman Lauder, and Adam D. Weinberg
Published by Aperture in partnership with the
Portland Museum of Art, Maine
September 2022
US $50.00 / UK £40.00

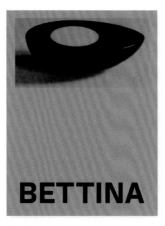

Bettina
Photographs and works by Bettina Grossman
Texts by Yto Barrada, Antonia Pocock, and
Ruba Katrib
Edited by Yto Barrada and Gregor Huber
September 2022
US $55.00 / UK £45.00

Tom Sandberg: Photographs
Photographs by Tom Sandberg
Essays by Pico Iyer and Bob Nickas
Conversation with Torunn Liven
September 2022
US $75.00 / UK £60.00

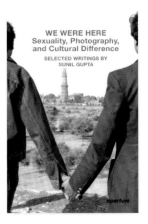

We Were Here: Sexuality, Photography, and Cultural Difference
An Aperture Ideas Book
Selected writings by Sunil Gupta
September 2022
US $29.95 / UK £22.00

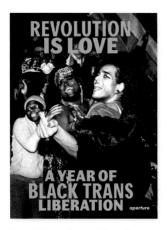

Revolution Is Love: A Year of Black Trans Liberation
Featuring images and text by
24 photographers
October 2022
US $45.00 / UK £35.00

Barry McGee: Reproduction
Photographs by Barry McGee
Texts by Sandy Kim, Ari Marcopoulos,
and Sandra S. Phillips
November 2022
US $60.00 / UK £50.00

Sam Contis: Overpass
Photographs by Sam Contis
Essay by Daisy Hildyard
November 2022
US $60.00 / UK £45.00

Kimowan Metchewais: A Kind of Prayer
Photographs by Kimowan Metchewais
Texts by Christopher Green, Emily Moazami,
and Jeff Whetstone
January 2023
US $75.00 / UK £60.00

Shop: aperture.org/books

aperture

Studio Visit

After years spent considering at the lives of others, Mikhael Subotzky picks up the pieces of his own life.
Kwanele Sosibo

To get to Mikhael Subotzky's studio in downtown Johannesburg from the unmissable Brixton Tower, which doubles as my location pin, one can either wade through the concrete jungle eastward, via Newtown or Braamfontein, or take the circuitous highway trip that heads south, then east, before reentering the city from the south, having made the shape of a sickle blade. This second option traverses intersecting overpasses, providing a sense of the fascination photographers have with this city where the sleek banking district gives way to abandoned skyscrapers and mine dumps that are still being extracted (both legally and illegally) for traces of gold.

The vast, warehouselike interior of Arts on Main, a compound of galleries and studios one meets on the descent, is the creative heart of the gentrified enclave that is the Maboneng district. Or, as Subotzky would have it, it's the nerve center of "the Kentridge industrial complex"—referring to the internationally renowned artist, who runs a collaborative, theater-driven space called the Centre

for the Less Good Idea. Having such a distinguished neighbor has rubbed off on Subotzky, a Magnum photographer whose work appeared in *New Photography 2008* at the Museum of Modern Art, New York, but who lately has ventured into painting and film. When we met earlier this year, he was preparing his newest film, *Epilogue: Disordered and Flatulent* (2022), for an exhibition at London's Goodman Gallery.

"Having a studio allowed me to experiment with different media," he says, seated on a chair placed along the short end of a Ping-Pong table in the center of the compact, mezzanined space he's worked in since 2009. Born in 1981, Subotzky grew up in Constantia, Cape Town, a suburb known for its winelands. He took up photography during a gap year prior to attending the Michaelis School of Fine Art, in Cape Town. His studio bears the traces of a man who has incrementally broadened his artistic practice.

Not far from the table, suspended like washing hung out to dry, is a line of ghostly portraits imprinted onto overlaid

strips of sticky tape, one depicting the image of the artist's face. They have an ephemeral, pained quality to them, suggestive of a rupture with a way of seeing. "I don't think I would have discovered this sticky-tape technique if I hadn't been trying to stick one of my photographs on a wall. I pulled the tape off, and I was just amazed at how clearly the image transferred," he tells me.

Subotzky's sticky-tape transfers have allowed him to stretch the possibilities of his increasingly labor-intensive practice. These techniques, as well as his expansion into film, painting, and collage, have facilitated an inward gaze that many white South African documentary photographers, including Paul Weinberg, Gideon Mendel, and David Goldblatt, have explored as they grappled with the cul-de-sac of social realism in a postapartheid setting.

In a country where the prospect of racial equality seems foreclosed, it is easy to read a breakout Subotzky work such as *Die Vier Hoeke* (2004–5), which documents conditions inside Pollsmoor Prison, as having been remarkable primarily for the mystery of the photographer's panoptic access to such a controlled space—a free rein mediated by racial privilege. The images engender a sense of discomfort—

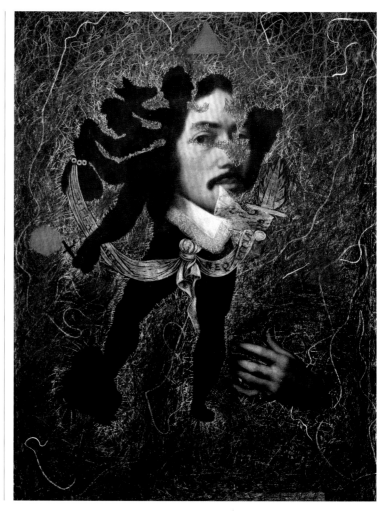

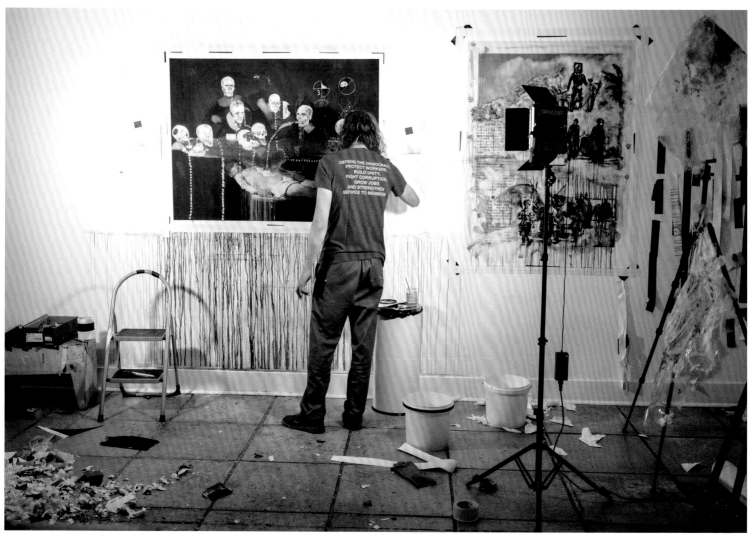

Subotzky's expansion into film, painting, and collage has facilitated an inward gaze explored by many white South African documentary photographers.

for both the viewer and the maker. "I don't in any way want to deny that there is something inherently strange and unnatural about the interaction that leads to a photograph being taken," Subotzky told the scholar Michael Godby in 2006.

Subotzky does not disavow his older work. Instead, he revisits it critically—elements of his oeuvre appear in *Epilogue*, layering his inquiry into white masculinity, father figures, and the violence of colonialism. He calls this film, the first he's edited himself, "the third of a triptych," which began with *Moses and Griffiths* (2012), in which he followed two elderly Black men as they gave tours of the colonial history of Grahamstown. Subotzky complicated their "psychological split" by superimposing their personal histories onto their scripted recounting of the 1820 settlers' exploits. With the stories unfolding simultaneously over four screens, he says, the "film was an expression of how a historical narrative is always incomplete." His second film, *WYE* (2016), also deals with the colonial experience from within, and was influenced by Robert Hughes's 1988 book *A Fatal Shore: The Epic of Australia's Founding*.

As we huddle around a corner of the Ping-Pong table, watching a rough cut of *Epilogue*, it becomes clear that Subotzky

has reached a point in his career where process seems poised to eclipse the importance of subject matter. While he uses the film to revisit his relationship with his father, who died in 2012, swap stories with a former prisoner named Hermanus, and reckon with his incredulity at Jan van Riebeeck's transformation from an "ugly" seventeenth-century Dutch gangster to a handsome father of the nation, he finds glee when discussing the textures of the images and the painstaking steps it takes to achieve those results.

Densely layered, many of the canvas-based images are vitalized by a driplike effect produced with water, which activates the pigments and allows them to be manipulated as Subotzky photographs them frame by frame for animation. The paper-based images involved his sticky-tape transfer method, "which is another canvas, so to speak," he says. "It wasn't satisfactory to me as just a film process."

For Subotzky, the overlay of narrative represents the structural nature of state violence clashing with the contained violence of family settings. It is a story he has been telling all along. Except this time, he suffers no delusions of grandeur.

Kwanele Sosibo is a writer based in Johannesburg.

Curriculum
Elle Pérez

Intimacy might be the biggest risk with the greatest reward, in life as in photography. Or so you might think looking at the work of Elle Pérez, whose striking images about love, desire, physical transformation, and emotional vulnerability have won wide acclaim in recent years, from a 2019 commission by the Public Art Fund in New York to a presentation in the 2022 Venice Biennale. Pérez grew up in the Bronx and photographed at underground queer spaces, making an indelible record of now-vanished venues. Today, their work—crystalline black-and-white landscapes or color portraits of queer subjects—speaks to a mastery of the fine balance between document and imagination, perception and performance.

E. Jane, *Where there's love overflowing*, **2022**

E. Jane is one of my favorite artists. Their recent exhibition at the Kitchen synthesizes a number of threads from their multipronged practice, which includes photography, drawing, sculpture, sound, video, performance, and an entire musical career as MHYSA, E. Jane's underground-pop-star alter ego. I admire their work as a site of archival care and recovery of the Black femme diva.

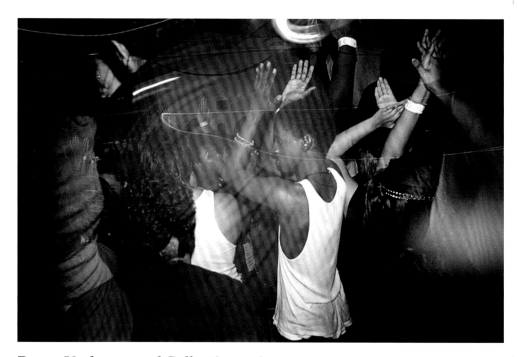

Bronx Underground Collective, 2001–15

As a teenager growing up in the Bronx, I had no idea how much the Bronx Underground (BXUG), which hosted concerts and dance parties for teens, would come to influence my life. At BXUG events, we were the center—there was nothing else that mattered to us, musically. I learned from BXUG how to form a coalition with a diverse group of people, a skill seeded by the generations of activists who had lived and made art in the Bronx before us. These activists were our parents, grandparents, and neighbors: former Young Lords, Black Panthers, and other leaders whose ideas about politics, conflict resolution, music, and love allowed us to benefit from lessons that were implicit within our communities.

José R. Oliver, *Caciques and Cemí Idols: The Web Spun by Taíno Rulers Between Hispaniola and Puerto Rico*, **2009**

Stone has long been a metaphor for the body in my work. My research into *cemís*, stone artifacts that are understood to literally contain the essence of individual people, has offered me a new way of thinking about how to view material, personhood, and portraiture—photography as not just a technology but a human impulse. For someone who has been trying to understand how to make a decolonial photograph, learning about *cemís* was a major breakthrough and formed the groundwork for the photographs I presented at the 2022 Venice Biennale.

The 70th Anniversary Issue

In *Aperture*'s first issue, published in 1952, the founding editors mapped out the reasons for bringing the magazine to life. With intelligence—and a hefty dose of earnestness—they sought to create a space for photographers and "creative people everywhere" to communicate and speak to one another. This was a daring endeavor at the time, a labor of love driven by an almost messianic belief that photography mattered. Building a community around the publication was essential to their cause. "Growth," they wrote, "can be slow and hard when you are groping alone." Photography was a lonely place back in the early 1950s. The medium wasn't yet widely appreciated as a serious form of creative expression, and so the founders sought to make the case for the power of a still image that "blazes with significance." That the magazine has continually remained in print for seven decades amid shifting notions of what photography is—and might become—attests to the strong will of the founders, and of those editors, equally indefatigable, who followed and kept the magazine going, even as print media, in the age of screens, seemed destined for the dustbin. We inhabit a vastly different image world today, but the mission of the magazine, oddly enough, or perhaps likely enough because of the founders' promising trajectory, remains consistent.

As editors, we are privileged to engage with photographers, artists, writers, and thinkers whose work provokes, challenges, *and* blazes with significance. We may be searching at times, or finding new footings, but we are never alone. For this seventieth anniversary issue, we drew on our community to assemble a publication that looks at the past with a view to the future. Seven photographers, through original commissions, each explore a decade of the magazine. Each was invited to consider a single issue, an article, an idea, or even an omission, which seeded the portfolios that follow. Iñaki Bonillas, Dayanita Singh, Yto Barrada, Mark Steinmetz, John Edmonds, Hannah Whitaker, and Hank Willis Thomas have all reanimated our past in revelatory ways.

Seven celebrated, incisive writers—Darryl Pinckney, Olivia Laing, Geoff Dyer, Brian Wallis, Susan Stryker, Lynne Tillman, and Salamishah Tillet—were given the same prompt: Tour our archive, see what's there. What captures your imagination? What questions are emblematic? They reveal that however much photography and this magazine evolved, sometimes radically, *Aperture* remained committed to thinking about the meanings of pictures, and all that might encompass. The expansive nature of the medium was a strength, and the magazine could surprise, take risks, move against the grain. *Aperture* might even be, as Pinckney observes, "a home for the most gentle weirdness." —**The Editors**

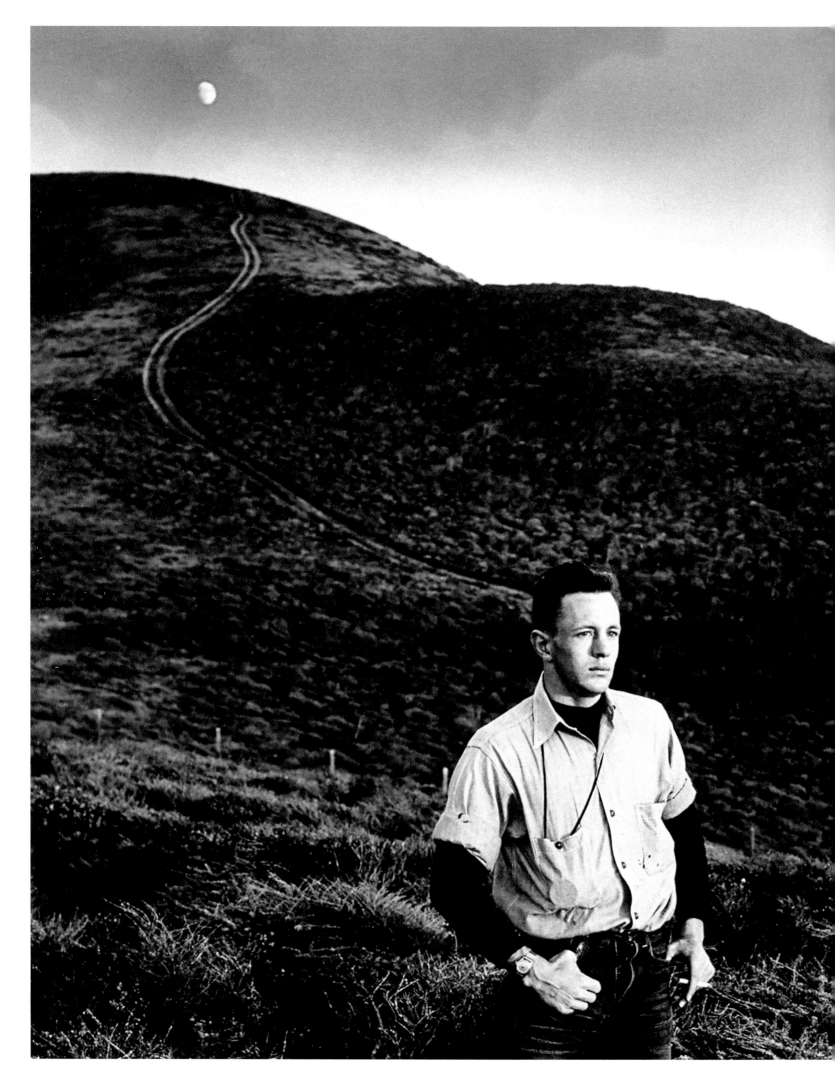

The Invention of Minor White

How did one of *Aperture*'s founding editors find spiritual liberation through photography?

Darryl Pinckney

The Wanderer, American-style. Minor White was born in Minneapolis, Minnesota, in 1908, and graduated from the University of Minnesota in 1934 with a degree in botany and a passion for poetry, two elements at the foundation of his work. White stayed in town, sentenced by the Depression to punitive work hours. In 1937, he began using a 35mm Argus C, James Baker Hall tells us in his biographical essay *Minor White: Rites & Passages*, in *Aperture*, Winter 1978, and properly equipped, meaning free at last, he got on a bus bound for Seattle. However, he got off in Portland, Oregon, and eventually found a job with the Works Progress Administration, making a series of early Portland architecture and another of the Portland waterfront, Hall says. There are photographs in *Rites & Passages*, taken from later periods, that remind us how much we love doors. Hall also tells us that White lived from and for photography for the rest of his life. He died in 1976.

He did not have opportunities to photograph much during World War II, as part of an army intelligence unit in the South Pacific, but from the hours, months, and years of introspection,

White identified the struggles of his life and thereby the themes of his work: his attraction to men; photography as symbol hunting. Settling in New York after the war, he was too shy to keep his first appointment with Alfred Stieglitz in 1946, but he made the most of all the others, and then that same year, he went back to San Francisco, where he joined, under Ansel Adams, the faculty of the California School of Fine Arts, as the San Francisco Art Institute was known at the time. He first encountered the f/64 group of San Francisco photographers, including Adams, in 1940. The group "prized sharply focused, tightly framed compositions and masterly printing," Paul Martineau writes in *Minor White: Manifestations of the Spirit* (2014). White liked the Speed Graphic for landscapes or a Leica for what he called his action shots.

When White accepted a position at George Eastman House in Rochester, in 1953, there was the upstate New York landscape he had to learn to appreciate. White then taught at MIT from 1965 until his retirement in 1974. Like W. H. Auden, White liked to live with his students, alive in an all-male novitiate community. He was fortunate, more or less, in the institutions he became associated with, especially *Aperture*, where he was editor from its founding in 1952 until 1975, his one-man band for the kind of photographs he wanted to feature. So he said. Its constellation of names has in it Barbara Morgan of the rhythmic photographs of the Martha Graham Dance Company; Edward Weston, the

first to be published in the magazine's monograph series; Manuel Álvarez Bravo, who initially learned by studying photography journals, although his work had a more social tone, with the Mexico of the 1930s as a subject; and the great Dorothea Lange, one of the magazine's founders, she who during the Depression documented in white poverty the nobility of its suffering.

"Much of White's best work, both as a photographer and as an editor, came directly and consciously out of Stieglitz's idea of the Equivalent, the photographic image as a metaphor, as an objective correlative for a particular feeling or state of being associated with something other than the ostensible subject," Hall writes in *Rites & Passages*. "Each man in his day embodied and promulgated that controlling idea by editing journals of comparable impact, Stieglitz with *Camera Work*, White with *Aperture*."

In San Francisco in the postwar 1940s, ideas that were Blake-descended, Whitman-sanctioned found original expression in White's own "camera work" of "self-discovery." San Francisco, refuge of iconoclasts, a port where sailors who weren't going home shared the adhesive democracy of shipboard brotherhood, a sexuality innocent and earned. Was not the new moon sinking through the troubled sky, as White describes in a long letter, twisting his revolving river of thought back on himself more than ever. It's because a sailor ran his hand over White's shorn head. "It feels good—like a brush," he recalls the sailor saying. An

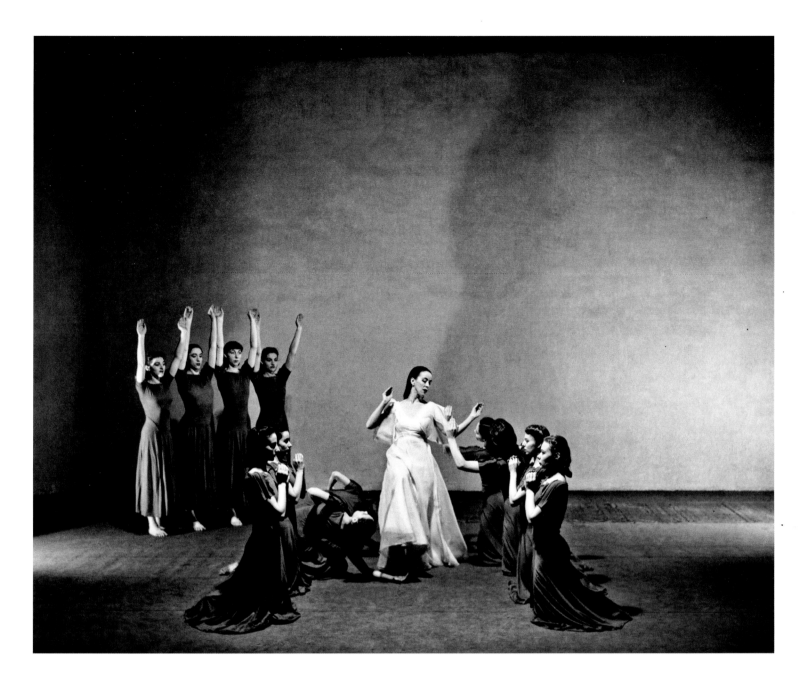

Barbara Morgan, *Martha Graham—Primitive Mysteries*, 1935, from *Aperture*, Spring 1953
Courtesy Barbara and Willard Morgan photographs and papers, Library Special Collections, Charles E. Young Research Library, UCLA

A search for a higher power is also a quest for order.

anonymous, rounded, black butt is not plant life, the photograph *Nude Foot, San Francisco*, made in 1947, announces.

It is impossible to look at White's black-and-white photographs of his student Tom Murphy, taken in 1947 and 1948, as anything less than a spiritual liberation. Tom Murphy's Michelangelo-like hands through a chair; his rough, veiny feet and the trouser cuffs of the period. Tom Murphy pensive, or sprawled on the rocks, or squatting on a wooded bank. This is his torso and his completely bizarre navel; this is his athletic torso in profile with his dick in shadow. He is photographed from behind, starting at the small of his back, a leg extended behind, about to become the release of a step. He is sitting on the floor, in the nude, a piece of driftwood between his thighs; he is reclining nude with driftwood, with a rose; he is seated alongside a table, not looking at the rose, then sitting up so his head is out of the frame. He is in quarter pose staring at his biceps, his hands crossed over his navel, his dick emerging from the pubic hair under his knuckles.

The photograph of Tom Murphy looking down past his left shoulder, his arms tightly crossed and his palms facing away from each other with his large navel in its bed of hair and muscle, says that Minor White was a man whose intense spirituality disguised a whacking big sex drive. He did not exhibit in full in his lifetime this thirty-two-photograph sequence, titled *The Temptation of Saint Anthony Is Mirrors*. "A cinema of stills," he called it. Whose

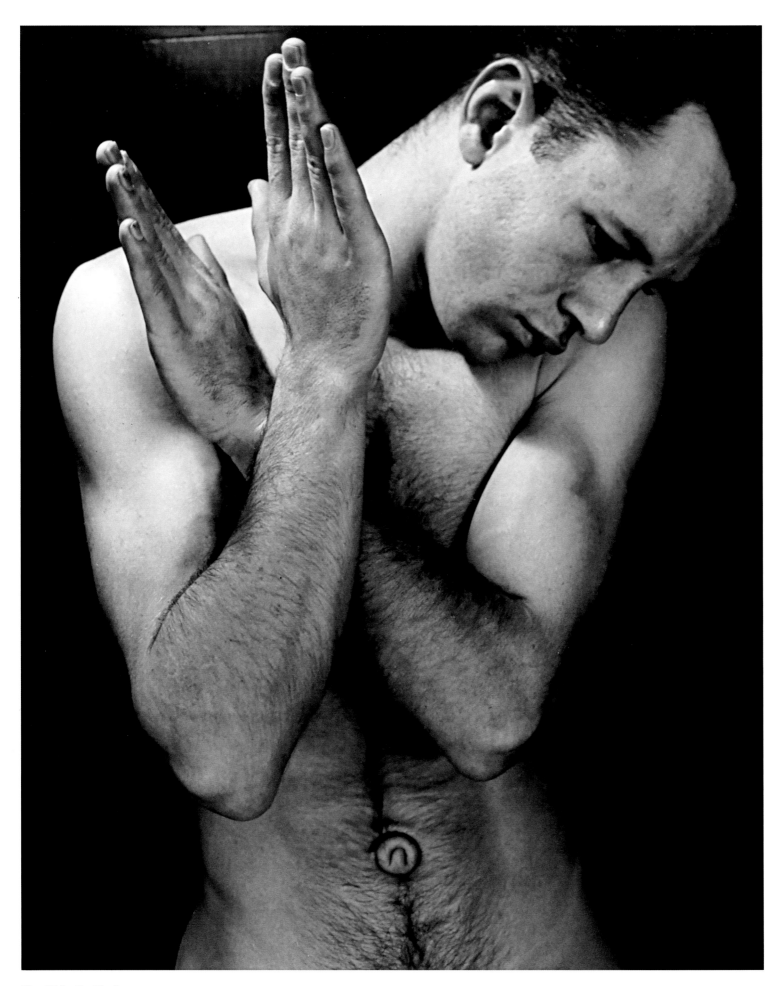

Minor White, *Tom Murphy,*
***San Francisco,* February**
1948
Courtesy Minor White
Archive, Princeton University
Art Museum

Spread from *Aperture*, Summer 1958, with photographs by Minor White

"A painter such as Paul Klee might have started from found objects or stumbled-on-accidents just as capricious as these and later "worked up" masterful paintings. But in altering, clarifying, revealing, might he not have really garbled a message already written lucidly by chance?"

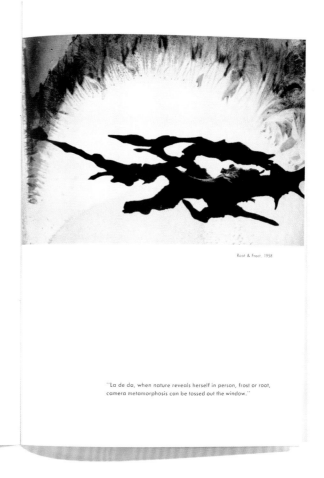

Root & Frost, 1958

"The moment of insight was metamorphosized into form."

Nude

"La de da, when nature reveals herself in person, frost or root, camera metamorphosis can be tossed out the window."

demons again? He once wrote to a woman that to love men could lead to Christ. He tried Roman Catholicism, and analysis, but found that cheerfulness and teaching worked. "I was fearful of loving Christ because of being shy of loving men." If you're queer, then you don't need the hisses of Sinclair Lewis's Zip City or Gopher Prairie. The twentieth-century laws that declared criminal his same-sex desires took him by one elbow while second-century church treatises that condemned his desires had him firmly by the other, and he guided himself toward transcendence. His liberation would seek expression through an odor of sanctity, a force field of piety, religiosity as deflection, hiding out in high seriousness. Purity of vision is absolution. The Russian philosopher George Gurdjieff was dead when, in the 1950s, his writing attracted White, who can sound in his sequence titles as the years went by as comfortably opaque as another follower of Gurdjieff, the black writer Jean Toomer, patiently waiting for the great fear to cross over into blessedness.

Find the dead bird on its bier of driftwood or identify what the dark field behind the angled white axe is composed of. Chart the motion of black branches floating on gray water, the swirling grain of bark, the ghostliness of stalagmites, the marriage of pebble and shore, the fugal sands of his desert. Here is the great sky of Wyoming, or a zooming California surf. A daydreaming windowsill is crisscrossed with shadows and reflections and planes and exposures. Ivy, rocks, beaches, tidal pools, barns, rooftop angles, shells, tire tracks in the snow, a parked truck, hellebores seen from above in a metal urn. In *Moencopi Strata, Capitol Reef National Park, Utah* (1962), we are either looking down into a valley or across a patch of rock. Often we are not supposed to know what things are. The photograph is the subject, the composition, the feeling, the light and the dark, the technique, the result, the aesthetic that sustained him beyond trends. He didn't publish or exhibit much of his work, and so there is now more to inform our sense of him, such as the use of color in some photographs in *Minor White: The Eye That Shapes* (1989).

A search for a higher power is also a quest for order. Look at the sculpture Time made of this rock; note the turbulent, worked-over landscapes, acted on by Time itself. His photographs ask Time of us, that we not just hit it and quit it, but look, look into what is going on. Be still. Observe. Be observed. He is engaged in a guerrilla war with the Tibetan Lord of Time. Who will blink first? Kalachakra or Minor White?

Aperture, a home for the most gentle weirdness.

Darryl Pinckney is a regular contributor to *The New York Review of Books*. His latest book is *Come Back in September: A Literary Education on West Sixty-Seventh Street, Manhattan* (2022).

**All works from the series
Compositions, 2022,
for *Aperture***
Courtesy the artist and
Kurimanzutto, Mexico City/
New York

Iñaki Bonillas

Compositions

For Iñaki Bonillas, photography is a form of archaeology. An artist who rarely makes images out in the world, Bonillas instead finds pictures that he clips, crops, and scales up to create new works offering enigmatic narratives. During his deep dive into issues from *Aperture*'s first decade of publishing—the 1950s, an era before photography had cemented its status as an art—Bonillas was struck by how the magazine, through its rigorous writing and exquisitely reproduced portfolios, endeavored to make the case for the richness, complexity, and expressive possibilities of the medium. From an essay by Nancy Newhall on image captions, citing Dorothea Lange's skillful use of language, to technically oriented writings on Ansel Adams's Zone System, the magazine brought readers defining articles that vibrated with the conviction of a manifesto.

Bonillas combines snippets of text and iconic images in a series of collages that feature open-ended statements and observations. "I'm an artist who is constantly asking what my main medium, photography, can still be, as art, in a time when photographic images flood our lives," he says. "In that sense, I feel very close to those in the 1950s who were, in a way, asking the same pressing questions. Photography as an art form is not something that I, in the twenty-first century, can take for granted—and neither could they, seventy years ago."

HAS PHOTOGRAPHY GONE TOO FAR?

Yes and no

Who cares?

I do not know

The problems of organizing a two dimensional surface

if he is lucky

he will find

among the rubbish

THE picture

Almost

always

the

photograph resembles

another

a photograph that literally sings

an ironic or absurd artifact

(which I suspect he himself
may have "accidentally"
put together)

mirror

with

a

memory

He would spend

the rest of his life

attempting to find out

Did You See Those Pictures?

From W. Eugene Smith to Dorothea Lange, the tensions between reportage, trauma, and artistry.

Olivia Laing

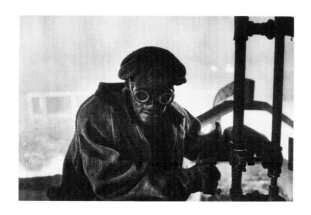

W. Eugene Smith

IN APERTURE MONOGRAPH

Cover of *Aperture*, Winter 1969

If the eye has a focal distance for any particular scene, might it also have a focal period, a time span in which an image can be apprehended in perfect focus? The idea occurs to me because of a possibility floated in the last *Aperture* of the 1960s, a monograph dedicated to W. Eugene Smith that gathers together his sublime expressionist images of atrocity, deprivation, and ordinary pleasure, from the invasion of Iwo Jima to Charlie Chaplin, Haiti, and the KKK.

In an afterword on Smith's work, subtitled "Success or Failure: Art or History," the critic, collector, and all-around polymath Lincoln Kirstein chews over the contested status of the photograph, coolly disparaging both its elevation to fetishized art object and its capacity for intercession in the realm of realpolitik. Nope and nope. A photograph can't stop a war. The notion that war causes injury and horror is news to no one, from Homer on. The evidence a photograph brings home has long since been preceded by maimed veterans and body bags unloaded from military vessels. But one thing Kirstein thinks a photograph might do is address the future, specifically the new world order of the twenty-first century: "They may have their small if solid use by that world then to show our world now."

In the same essay, Kirstein says of the photographer, "His greatest service is the seizure of the metaphorical moment." That's

a great, if weirdly organized, sentence. You might more typically be inclined to write it as verb, not noun: "to seize," as in *snatch* or *secure*, rather than "the seizure," which carries with it simultaneous meanings of *possessing* and *going into spasm*. *Seizure* is not so dissimilar to Roland Barthes's punctum, with its suggestion of an image that arrests the heart.

I want to take Kirstein at his word, to see what the world of the '60s looks like from the platform of now, seen by way of a few seizures of the metaphorical moment that caught my eye. Let's start in Fall 1961, with a sequence by Wynn Bullock that seems, at first glance, concerned with natural surface textures, especially where they offer stark contrasts. Redwoods, abandoned cabins, a collapsing bank. The standout picture is of a burned chair against a burned wooden wall. It's an account of aesthetic process, a fascinated investigation into the sheeny, scaly properties of charcoal. But hasn't something unpleasant happened here, to folk unknown? One of the costs of seizing the metaphorical moment is that it necessitates severing the threads of narrative.

Bullock's burnt chair exemplifies a tension that runs right through the '60s issues, made under the ardent stewardship of Minor White, between what a photograph can be and what a photograph can show, which is to say the artistic impulse versus that of documentary. Take *Bad Trouble over the Weekend* (1964) by Dorothea Lange, from the Fall 1969 issue. The down-home phrasing serves as an additional button of veracity on this portrait of devastation, testimony to a dire sociopolitical situation. Yet the surfaces are as finely recorded as Bullock's: knitted collar, worn wedding band, thin hair, thin hands covering the face, the black stub of a cigarette. It's a Raymond Carver story condensed to a

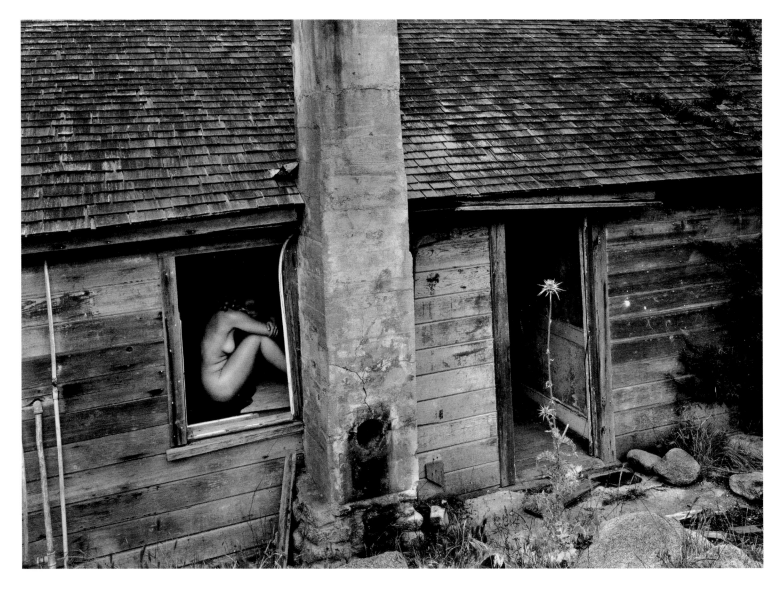

Spreads from *Aperture*:
Summer 1965, with
photographs by Edmund
Teske; Winter 1969,
with photographs by
W. Eugene Smith

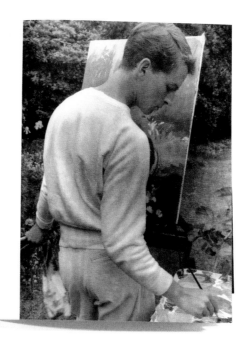

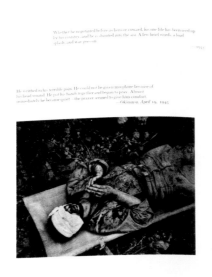

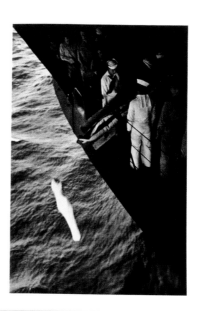

Even the most fantastical image betrays something about the world, not to mention about the person making it.

single frame, a universal semaphore for distress. And the cause of the trouble? Long gone, along with the subject's name.

Ray K. Metzker, whose sequence *My Camera and I in the Loop* appears in the Summer 1961 issue, is particularly articulate about the slippage between image and record. A choreography of solid bodies—cuffed/shirted/skirted/shod in white—emerges from slabs of urban dark, as theatrical in their composition as anything by Edward Hopper or Fritz Lang. Hardly reportage, except it is. "I began shooting," Metzker explains, "in accord with my socioliteral viewpoint. The resulting pictures could not stand alone; they needed the propping of verbal explanation to exist." Gradually, over the course of a painful winter, he saw that a photograph wasn't anything save a "composition of light." What it communicated or recorded was not as important to Metzker as the encounter between camera and eye: "To photograph is to be involved with form in its primal state."

But is pure form any more attainable than pure reportage? Even the most fantastical image betrays something about the world, not to mention about the person making it. The Summer 1965 issue includes a series of dream scenes constructed by Edmund Teske. They're layered, pictorial, artificial, melancholic, wistful, fey. Toward the end of the run, there's a portrait of a man painting, his

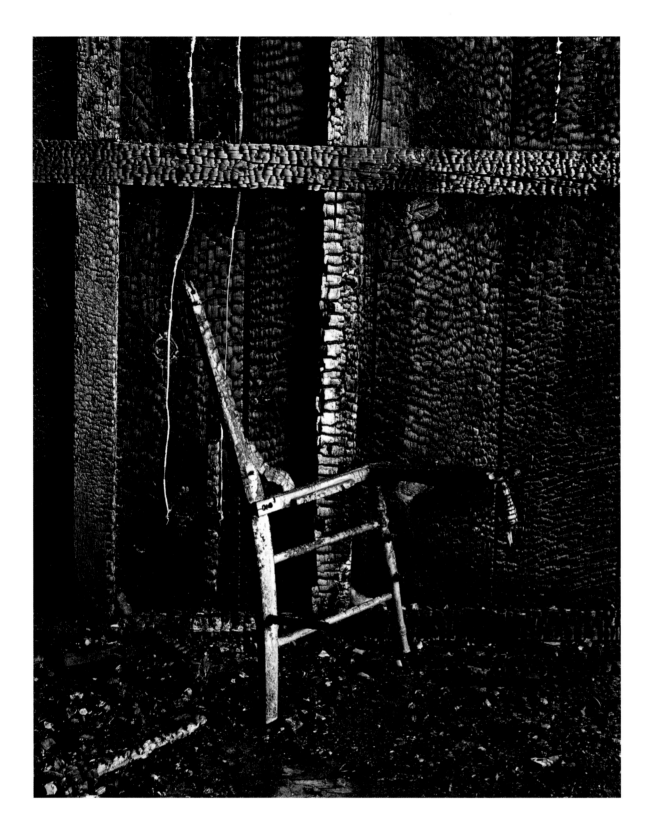

This page:
Wynn Bullock, *Burnt Chair*,
1954, from *Aperture*,
Fall 1961
© Bullock Family
Photography LLC

Opposite:
Ray K. Metzker, *58 EM-33,
Chicago – Loop*, 1958,
from *Aperture*, Summer
1961
© Estate of Ray K. Metzker
and courtesy Howard
Greenberg Gallery,
New York

cold hawk's face in profile. The eye travels down a lovely ogee: nape, shoulder, buttock. Something unsaid here, a secret pulse.

This curve reminds me of another story Kirstein told. His essay on Smith culminates with a little epilogue, the story of an anonymous journalist friend he calls Jerry. It's 1942, and Jerry doesn't want to be drafted. Finally, one hard-drinking night, he admits he'll say he's queer rather than risk being shot up. Kirstein needs to use the bathroom; Jerry doesn't want to let him. When Kirstein does finally enter, he discovers the room is pasted floor to ceiling with Smith's photographs of the Pacific landings, stolen from the *Time* magazine offices. Dead boys in Eden. "Did Jerry sit there and amuse himself by shots of Tarawa?" Kirstein wonders cruelly. "Now you know," Jerry says as Kirstein reemerges. "I can't take it. I'm scared. Did you *see* those pictures?" When Kirstein comments mockingly on their beautiful composition, poor Jerry cries out: "They're *real*."

I wonder, was Jerry a good reader of photography or not? He refused to accept the photograph as a composition of light. For him, it was a memo from the future: watch out. Everything extraneous had been scraped away, until there was just the moment, a seizure that could stop the heart. Who knows what the boys were called, or even what they'd done. It was the pictures that were real now.

*Olivia Laing is the author, most recently, of
Everybody: A Book About Freedom (2021).*

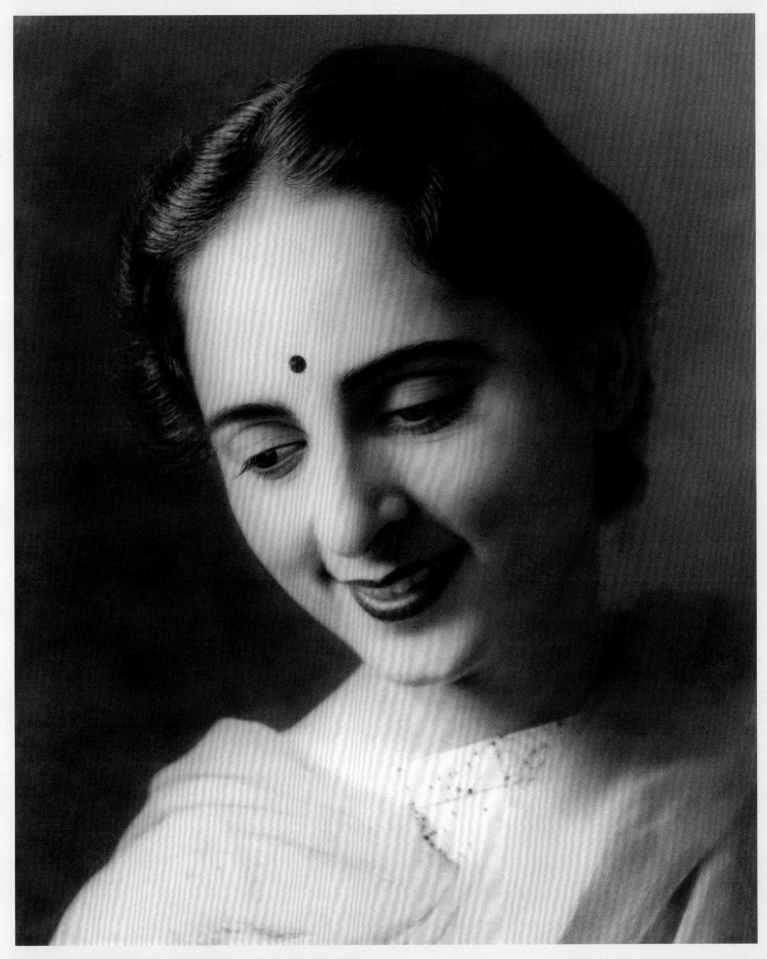

Nony Singh married Kanwar Mahinder Pal Singh in 1960. Her father-in-law was so pleased that his casanova son had agreed to marry that he gave Nony his Zeiss Ikon, which hung on his shoulder. After their marriage, Mahinder took Nony to a photo studio and photographed her in this pose. Later he hand-colored this photograph, as he often liked to do.

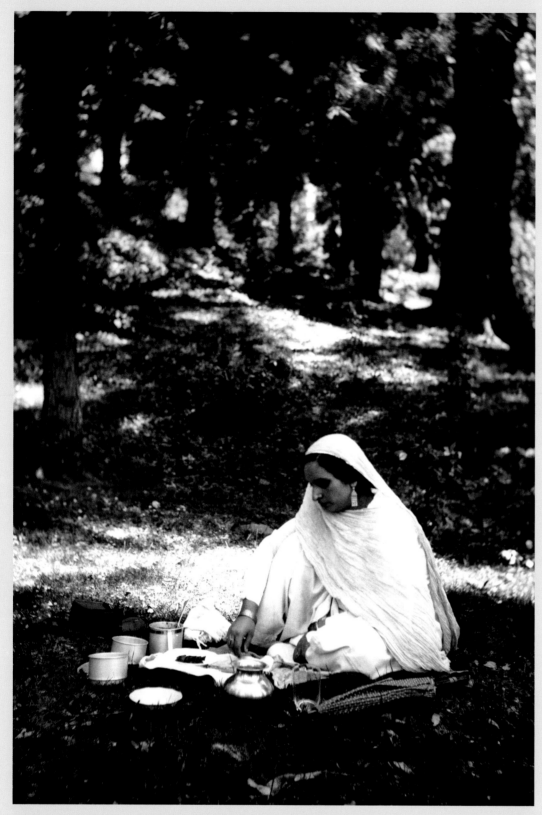

Nony Singh had been photographing since she was seven years of age. This is one of the first photos she took of her mother in Koh Murree, near Rawalpindi (now Pakistan), 1943.

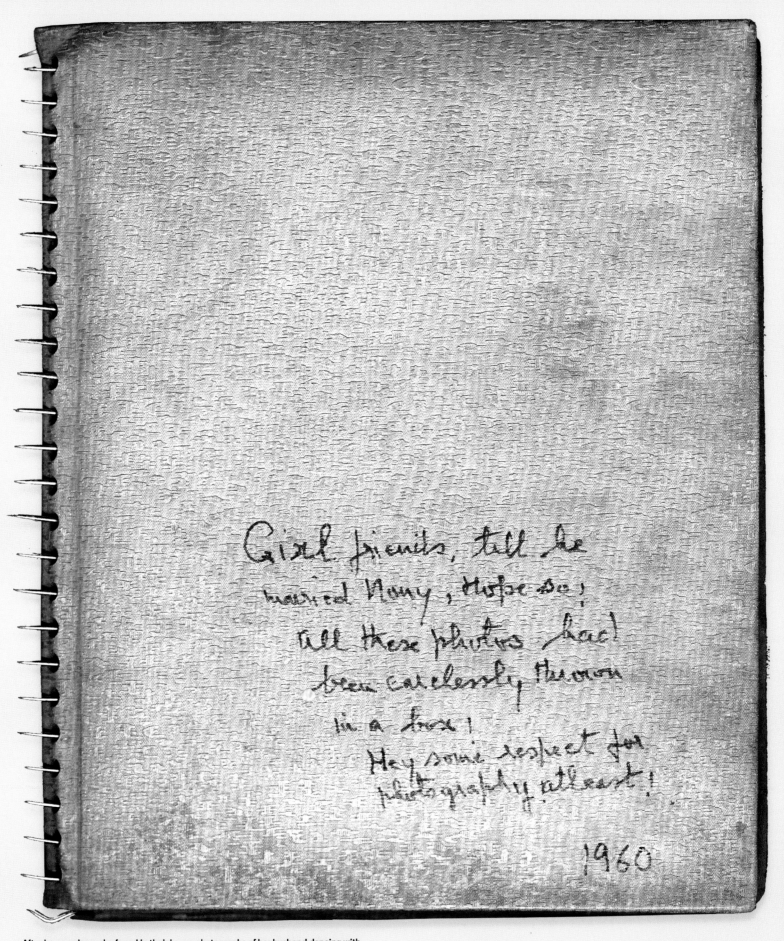

Girl friends, till he
married Nony, Hope so;
All these photos had
been carelessly thrown
in a box!
Hey some respect for
photography at least!

1960

After her marriage, she found in their house photographs of her husband dancing with various women. She collected them and made an album, placing her own photo on the last page. "Girlfriends, till he met Nony, Hope so! Hey, some respect for photography at least."

Nony pasted the images into an album, building her own narrative. She also wrote comments behind some of them. "She should have married my husband, she looks so bored with her diplomat husband."

On the last page of the album, she placed her own photograph.

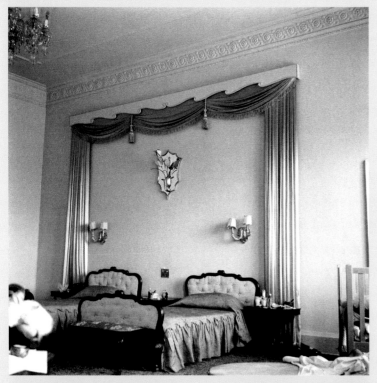

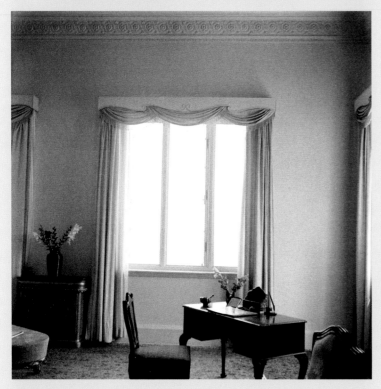

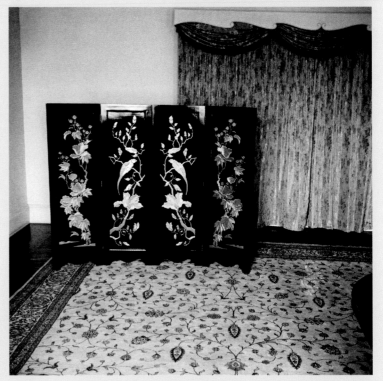

When she had their first child, in 1961, Mahinder took Nony to Srinagar for a celebration of their new arrival. She had often fantasized about staying in a five-star hotel, so Mahinder booked them in a suite in the Oberoi Palace Hotel. Nony photographed every detail in the room, the twin beds in a double room, the ornate lamps, the desk by the fireplace, and even a wooden screen, 1961.

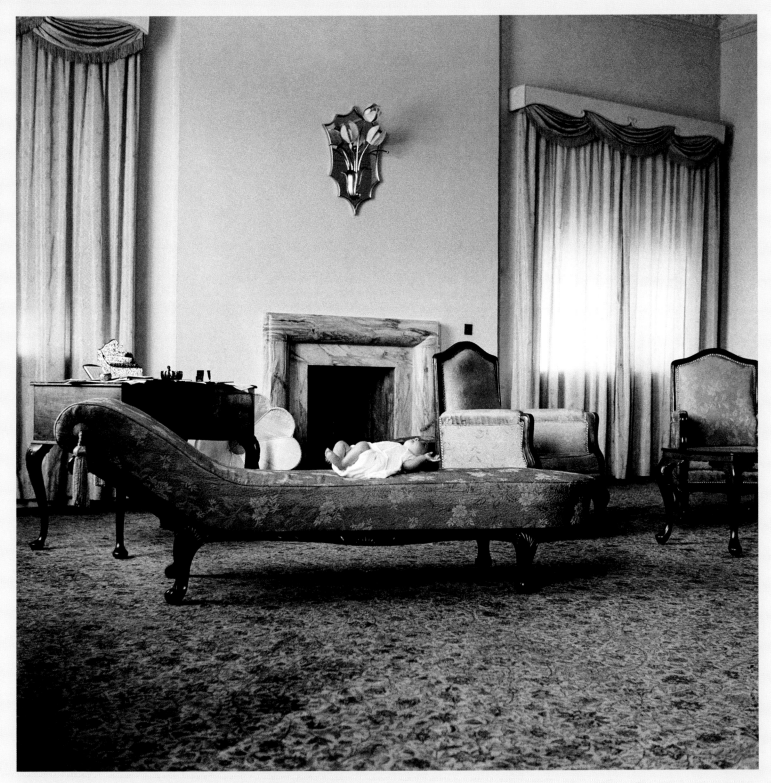

She then realized that she had to make it clear that she had stayed in that room, so she placed her firstborn on a chaise longue and made this photo. Six decades later when her firstborn won the most prestigious photography award, she said, "She got her freedom from me when she was six months old. I placed her on this chaise longue to click a photo, imagine the chance I took when I made this photo. Seeds of freedom?" 1961.

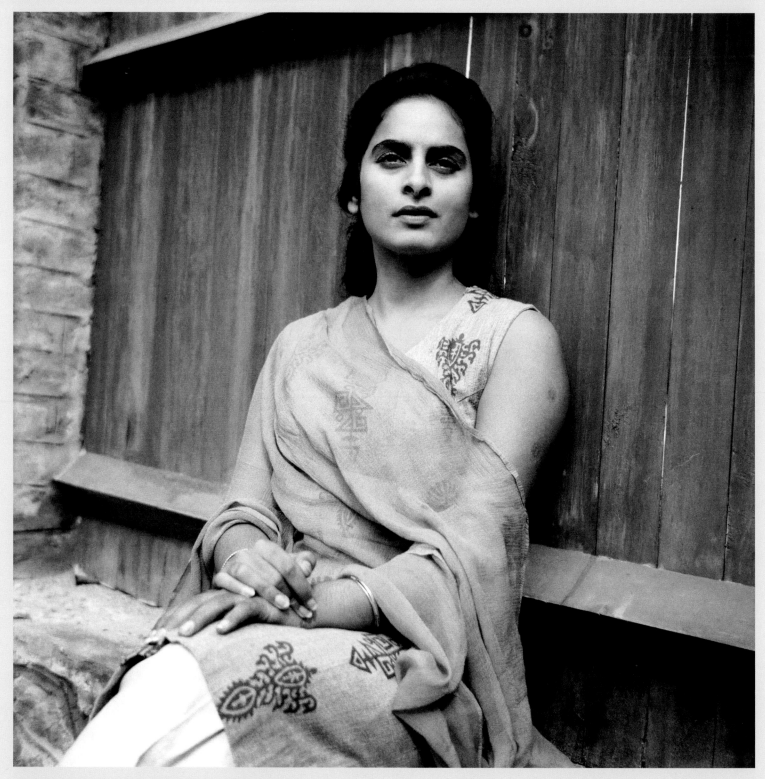

Nony loved to photograph her family (they were also all that she had access to) and posed her sister as Scarlett O'Hara after seeing *Gone with the Wind*, 1962.

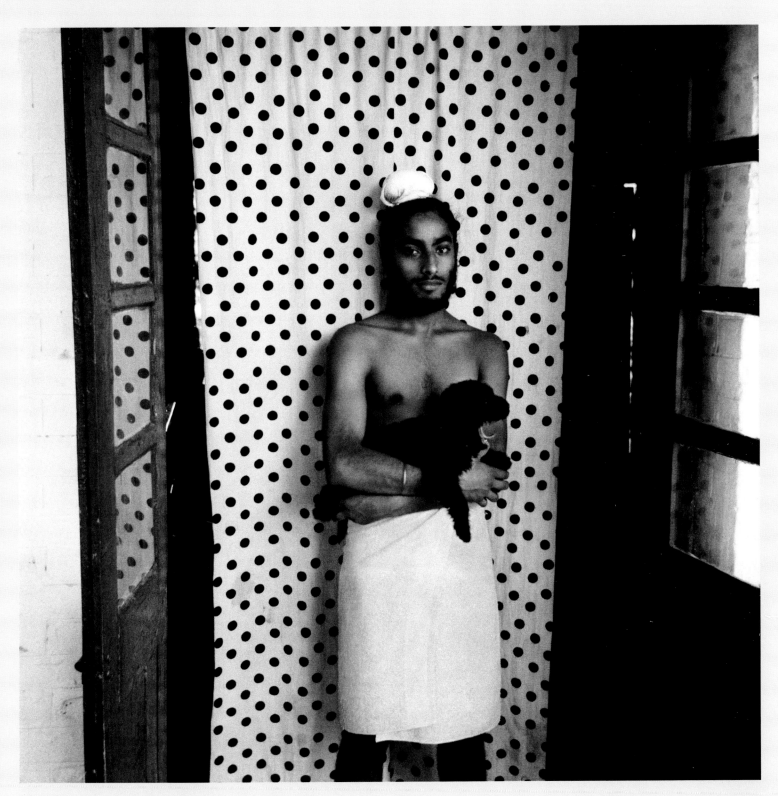

One of the rare photos that Nony made of a man, her cousin and his dog, 1966.
All photographs courtesy the artist

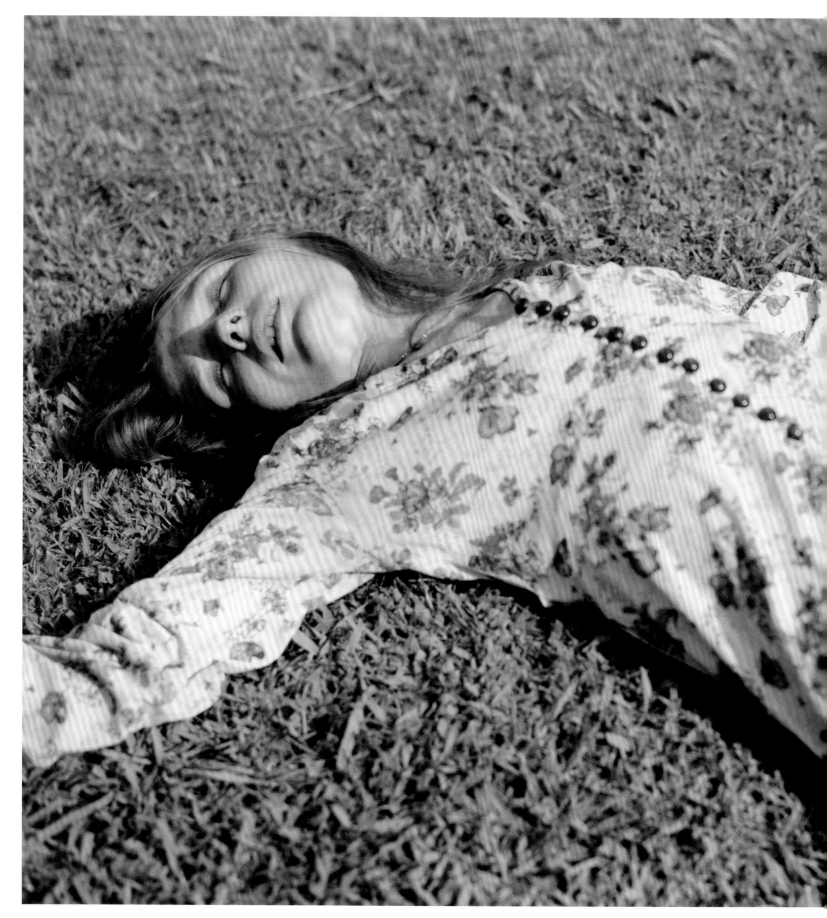

William Eggleston,
Untitled, **1975**
© Eggleston Artistic Trust
and courtesy David Zwirner

stone that was never hidden or lost, merely taken for granted and, thereby, easily overlooked. It is also a yardstick by which to assess what is going on in photography now. A single axiom can never be relied on to determine value in any medium, but Szarkowski's has proved more reliable than anything else written about photography. It could help us today, saving a lot of time, sparing our eyes unnecessary exposure to all manner of visual froth and nonsense.

Geoff Dyer is the author, most recently,
of *See/Saw* (2021) and *The Last Days of
Roger Federer* (2022).

All photographs from the series *Bettina's Color-aid papers with 1970s Aperture issues*, 2022, for *Aperture*
Courtesy the artist with Charles Benton; Pace Gallery, London; Sfeir-Semler Gallery, Beirut and Hamburg; and Galerie Polaris, Paris

Yto Barrada

Bettina's Color-aid Papers

The photography of the 1970s was marked by competing visions, looking both forward and backward in time. *Aperture*'s entry into the decade, with a Spring 1970 issue on early French photography, mined the medium's austere origins in the previous century, while the emotive force of more immediate "snapshots" by Garry Winogrand, Nancy Rexroth, and Joel Meyerowitz collected just a few years later, in the Fall 1974 issue, confronted us with the medium's potential and scope.

In framing this range, the magazine, too, wore many faces through the decade, featuring monographs, thematic explorations, and shifts in appearance. "The size, the format, the design all changed across the 1970s issues," remarks Yto Barrada, revisiting *Aperture*'s archive. "I tried to follow the object," she explains, "to trust the directions given by it and its encounter with the other objects in my studio." The other objects, in this case, were Color-aid cards of

the late artist Bettina Grossman, whose work spanning sculpture, painting, photography, and textile design has only recently gained wider recognition, in large part because of Barrada. Placing and photographing the decade's issues against the faux leather of her studio table, Barrada composes images from the material remnants of Bettina's color paper cutouts, the kind often used by artists and designers. Here, Paul Caponigro's solitary tree on the Winter 1979 cover is partially obscured, as are two of Helen Levitt's lively New York City street scenes from the pages of the Summer 1975 issue. Inspired by Bettina's approach and the magazine's history, Barrada's recompositions are also re-formations, attempts at a new grammar, yielding unexpected associations. "I first chose to conceal the photographs and then began to compose in an automatic way," Barrada reflects, "like an exquisite corpse."

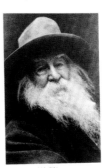

Portrait of Walt Whitman, c.1842.
Walt Whitman House, Camden, New Jersey.

alt Whitman, Brooklyn, c.1872. Photograph
r Frank Pearsall, New York Public Library.

Walt Whitman.
Photograph by George C. Cox, New York.
New York Public Library.

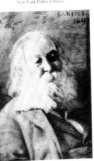

Portrait of Whitman about 1854, age 35,
just before the first publication of Leaves of Grass.
Duke University Library, Trent Collection.

Walt Whitman.
Photograph by Thomas Eakins, 1891.
Yale University Library.

Walt Whitman. Painting by Thomas Eakins,
1887–1888. Pennsylvania Academy of the Fine Arts.

atherstone

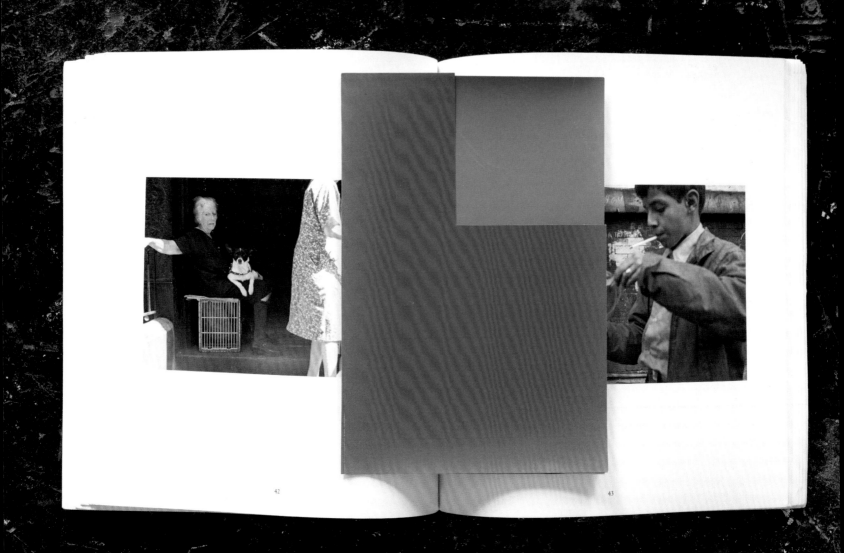

42

43

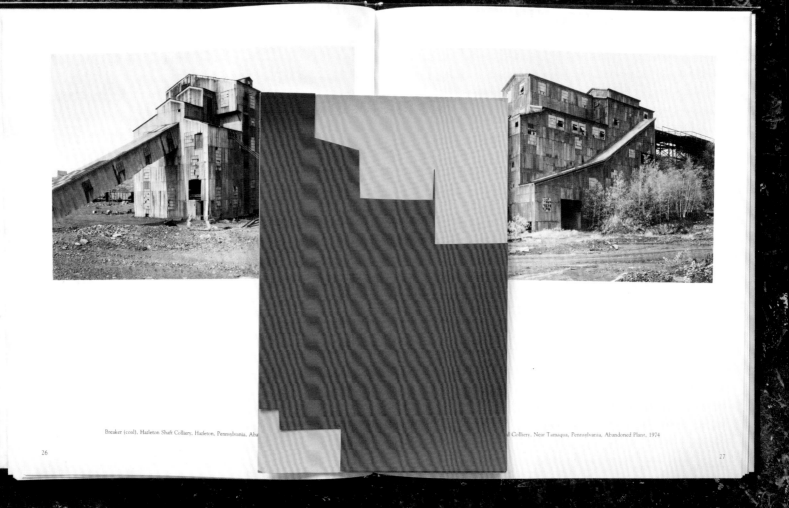

Breaker (coal), Hazleton Shaft Colliery, Hazleton, Pennsylvania, Abad Colliery, Near Tamaqua, Pennsylvania, Abandoned Plant, 1974

26

27

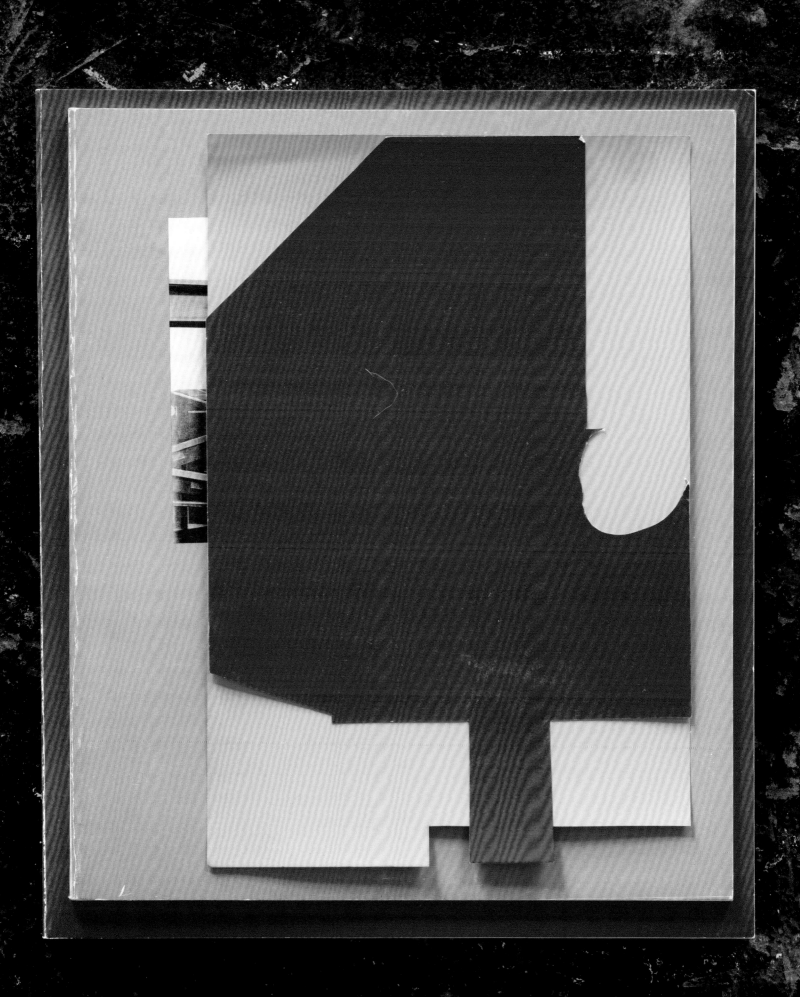

Edges of Illusion

At a time of burgeoning culture wars, artists confronted fundamentally political questions about identity.

Brian Wallis

"Photography was not a bastard left on the doorstep of art, but a legal child of the Western pictorial tradition," insisted the Museum of Modern Art photography curator Peter Galassi in 1981, somewhat defensively. At the time, photography was still not widely accepted as a legitimate art form and was scarcely represented in the collections of major art museums. Art and photography existed in distinct and separate domains. Fine-art photography was pursued by the avid few and was always distinguished as being superior to commercial photography and photojournalism. Art photographers and curators generally seemed preoccupied with formalist issues of light and composition and with technical complications of equipment and analog printing—as opposed to, say, concerns of social or political import. The tiny world of art photography, with few galleries and little critical discourse, was largely dominated by two judgment seats: the photography department of the Museum of Modern Art (MoMA), then headed by the curator John Szarkowski, and the book and magazine publisher Aperture, guided by its executive director, Michael E. Hoffman. These two institutions functioned, often in tandem,

as the principal advocates for the validity of photography as an artistic medium.

The issue for most viewers was not that photography was too modernist or too experimental but rather that it was either too ubiquitous or too esoteric to take seriously, an arcane subject best left to connoisseurs and elderly men with muttonchops. This last position was always symbolized for me by the black-and-white image on the cover of the Spring 1980 *Aperture* magazine: August Sander's 1931 portrait *Pharmacist, Linz*, a full-length standing view of a stout and rather severe German man with white hair and beard, dressed in a conservative three-piece suit, feet planted firmly apart, one hand thrust into his pocket. This was old-school photography. The monographic text by the historian Beaumont Newhall, who had founded the MoMA photography department in 1940, emphasized the traditional, documentary quiddity of Sander's straight photography. Newhall approvingly quoted Sander's 1931 radio lecture in which he stated: "The essence of all photography is of a documentary nature, but it can be uprooted by manual treatment. . . . If we compare, we will ascertain that a photograph

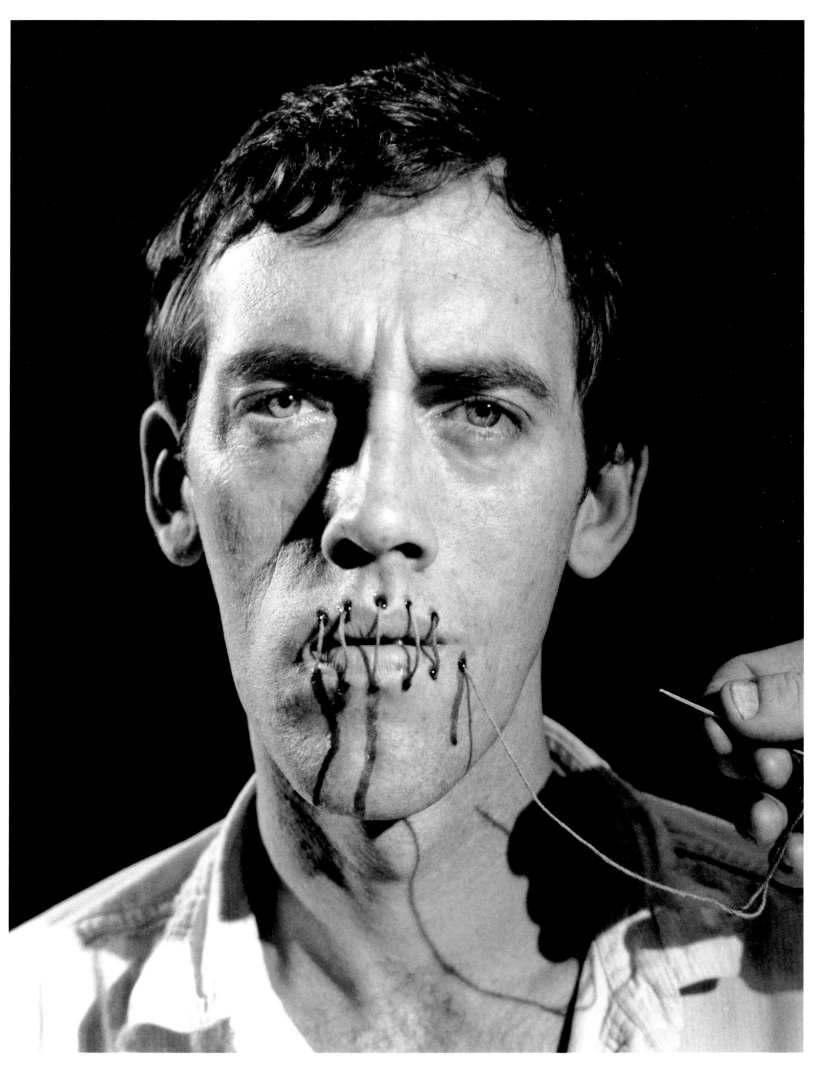

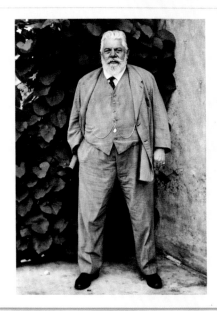

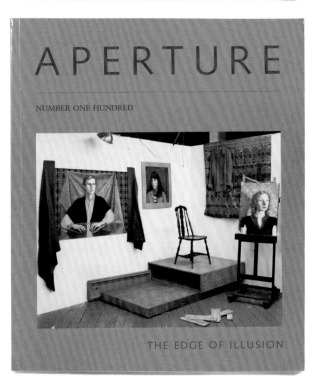

This page:
Covers of *Aperture*: Spring 1980, a monographic issue on August Sander; Fall 1985, with photograph by David Graham

Opposite:
Cindy Sherman, *Untitled*, 1983
© Cindy Sherman and courtesy Hauser & Wirth

produced with the aid of chemicals is far more aesthetic than one muddled by artificial manipulation."

For me, Sander's self-satisfied pharmacist symbolized the perceived authority of the largely male-dominated photography community of the time. His assertiveness was an allegory for rock-solid confidence in a knowable version of reality as depicted by photography, and commonly accepted as realist evidence, or "the truth." But at that very moment in the early 1980s, photographic truth and the traditional modernist notions of authenticity and objectivity were being roundly challenged by an upstart band of contemporary artists and postmodernist critics. Influenced by French theoretical models, writers on photography, such as Rosalind Krauss, Craig Owens, Abigail Solomon-Godeau, Douglas Crimp, Martha Rosler, and Allan Sekula, argued that photographic representations were not neutral evidence but adhered to historically specific and ideologically freighted concepts meant to serve regulatory social and political goals.

Their provocative arguments were articulated in publications on art, photography, and critical theory ranging from the recondite *October*, to the glitzy *Artforum*, to a proliferation of smaller journals such as *Screen*, *Afterimage*, *BOMB*, *Block*, *Wedge*, *Semiotext(e)*, and *REALLIFE Magazine*. This discursive framework encouraged surprisingly innovative artistic practices among a small cadre of New York artists. Refusing to be labeled photographers, these "artists using photography," as they called themselves, active in the late 1970s and early 1980s, included Richard Prince, Sherrie Levine, Sarah Charlesworth, James Welling, Barbara Kruger, and Cindy Sherman, among others. Having been raised on a fulsome diet of television, film, advertising, and broadcast news, these artists adopted such media-savvy tactics as appropriation, rephotography, montage, staged images, bold typography and graphics, parody, and humor to skewer photographic pretensions.

Halfway through the decade, *Aperture*—now just one among a growing number of publications of cultural criticism—finally addressed this alarming rupture in the otherwise self-confident practices of straight photography. For the Fall 1985 issue, the magazine's one hundredth, pointedly titled "The Edge of Illusion," the seemingly bewildered editors reported that "the representational, descriptive intentions of so much 19th-century photography, and the modernism and symbolism of Stieglitz's equivalence, remain permanent qualities of the photographic tradition. In 1985, that tradition is challenged not only by photographers but by those artists whose work is derived from photographic practice. They provide profound comment on the nature of photographic evidence. . . . The sanctity of the photographic print is overturned, exposing a tradition from which so much of this work appears divorced." As if to prove this point, the issue included a rather jarring interview with the artist Richard Prince, then known primarily for rephotographing magazine advertisements. Though glib about his uses of photography, Prince was remarkably clear about his mission: "I'm not just making another fiction. That wouldn't interest me at all. I'm interested in the fiction becoming true. . . . The fact that my pictures already exist in public helps to establish their reality. I obviously don't make the images up. My style is hopefully a convincing style. Rephotography is photographing what's already been determined, so obviously rephotography is about overdetermination. Basically, I'm not interested in impressions, and I like to think I'm in the habit of telling the truth."

Three years later, as a young writer, I published my own critical take on photographic fictions in *Aperture*'s Fall 1988 issue, with an essay titled "Questioning Documentary." Advocating for lesser-known nonwhite and nonmale photographers—or, at least, artists using photography—I cited the works of Judith Barry,

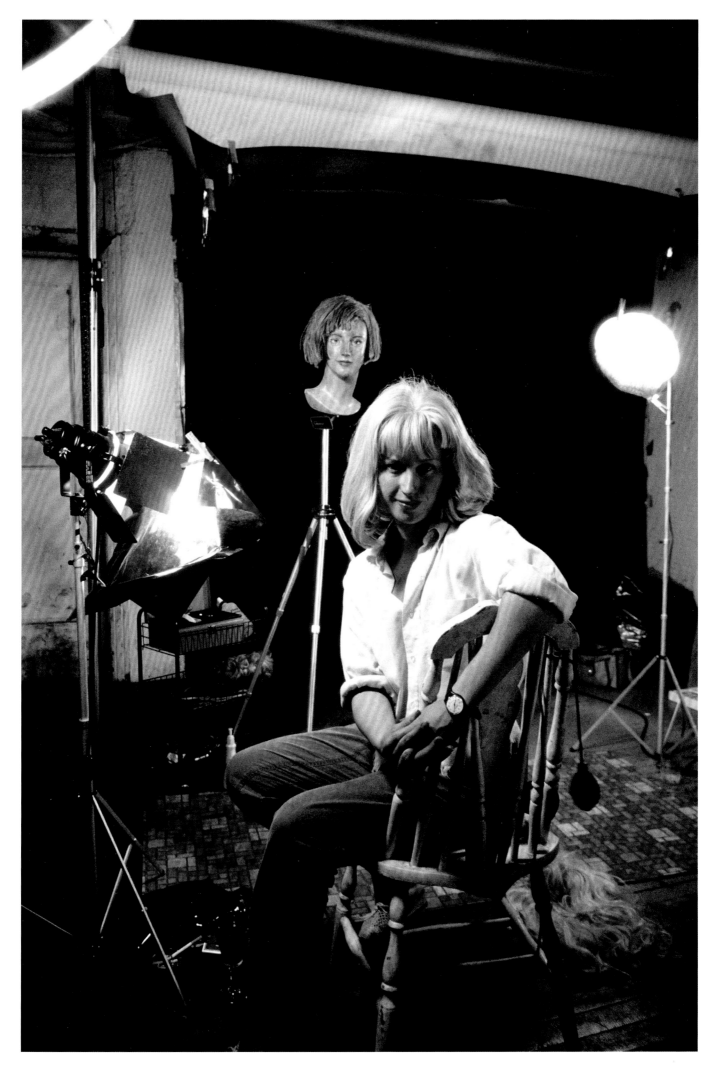

The increasing visibility of feminist, queer, and nonwhite artists with subversive political messages ultimately drew the ire of conservative American politicians.

Barbara Bloom, Lorna Simpson, Trinh T. Minh Ha, and Carrie Mae Weems as revealing an original direction for the medium. These artists saw photography not as fixed imagery but rather as a constructed language with fluid meanings that changed with each new context and subjective reading. Using found photographs and texts, their works claimed an active role for the viewer and sought to intervene in the implacable truth of photography through the skillful adaptation of fictional narratives or other forms of storytelling—the inauthentic, the staged, the imaginary.

These deliberate recastings of modes of address and this wholesale refashioning of phallocentric photographic representation were often presented by postmodernist artists with deft irony and humor; one prominent 1983 exhibition was titled *The Revolutionary Power of Women's Laughter.* Fiercely feminist artists sought to turn the patriarchal photographic gaze on itself: Sherrie Levine repositioned prominent photographic icons by male photographers as if seen through her own authorship; Cindy Sherman in her *Untitled Film Stills* (1977–80) placed women in vulnerable positions before an implicitly predatory male viewer; and Barbara Kruger used pungent pronouns typographically overlaid on found photographs to reveal abusive masculine privilege ("Your gaze hits the side of my face"). Often these works had a public manifestation. For a major pro-choice march in Washington, D.C., in April 1989, Kruger designed a flyer that featured text over the black-and-white photograph of a woman's face divided into negative and positive halves. The words announced, "Your body is a battleground." Between 1987 and 1990, many collectives devoted to AIDS activism, such as ACT UP and Gran Fury, also adopted such declamatory uses of text and photographic images on public art, videos, and posters to challenge the U.S. government's willful inaction and public silence in response to the AIDS crisis.

The increasing visibility of feminist, queer, and nonwhite artists with urgent and subversive political messages ultimately

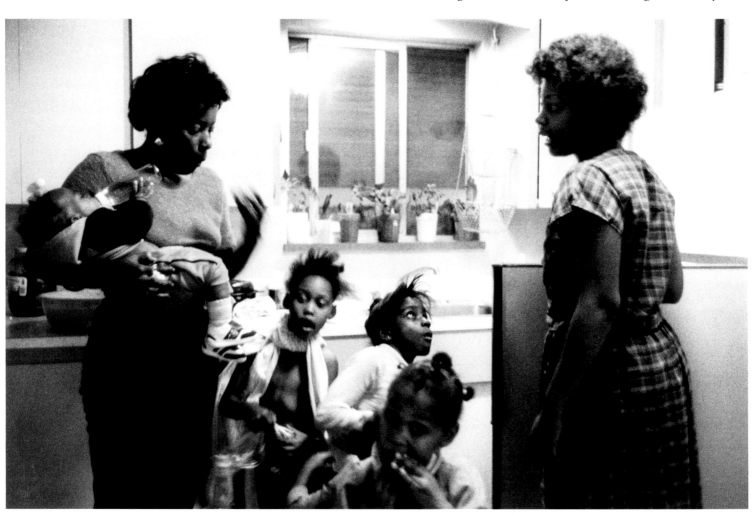

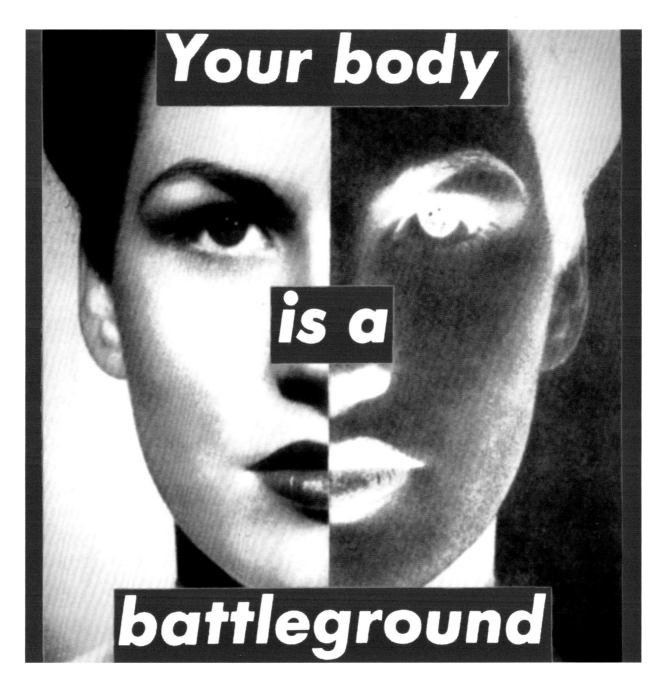

Barbara Kruger,
*Untitled (Your body is
a battleground)*, 1989,
from *Aperture*, Fall 1990
Courtesy the artist,
The Broad Art Foundation,
and Sprüth Magers

drew the attention and ire of conservative American politicians. Virulent public opposition to individual works or series by the photographers Robert Mapplethorpe, Andres Serrano, and David Wojnarowicz, in particular, challenged the legality and public display of certain controversial depictions of sexuality, religion, and patriotism. Their uses of photography to engage fundamentally political questions elicited a firestorm of national controversy around art, known as the "culture wars." In 1989, congressional authorities sought to curtail grants to a regional art space for showing the work of Serrano; later the same year, the National Endowment for the Arts withdrew funding for an Artists Space exhibition on AIDS for publishing an essay by Wojnarowicz; and in 1990, the director of the Contemporary Arts Center in Cincinnati was brought to court and charged with obscenity for showing photographs by Mapplethorpe. Rather than a critical judgment on the work itself, the operative political issue became the rights of these artists to speak out, to show certain photographs, and to make unabridged comments in public spaces.

These national debates were forthrightly addressed in what might be considered the last *Aperture* magazine of the 1980s, the remarkable Fall 1990 number titled "The Body in Question." Tackling questions of sexual representation and censorship head-on, this issue marked a conspicuous departure from *Aperture*'s past valorization of apolitical versions of photography. It featured essays by the noted writers Carole S. Vance, Edward de Grazia, Tom Kalin, Katherine Dieckmann, and Allen Ginsberg, and bravely published Wojnarowicz's contentious *Sex Series* (1989). Even more conspicuous and controversial was the publication on its cover of Sally Mann's daring image of her four-year-old daughter Virginia, standing stark naked, arms akimbo. With her defiant frontal stance, Virginia Mann provides a striking visual contrast to Sander's conservative German pharmacist published ten years earlier. Between these two *Aperture* covers lay a decade in which the social purpose and meaning of photography and visual culture was repeatedly raised and questioned. What appeared at the time to be a political flashpoint or an epistemological debate might, in retrospect, be seen as a revolution in thinking about photography.

Brian Wallis is a regular contributor
to *Aperture*.

Mark Steinmetz

Irina & Amelia

"*Mothers and daughters!* Are there any fantasies or ideal images left to us in this tough-minded age of psychological realism?" So begins the historian Estelle Jussim's essay for *Aperture*'s Summer 1987 issue, "Mothers & Daughters," a catalog in magazine form that accompanied a traveling exhibition of photographs about mother-daughter relationships. "That Special Quality," the suggestive subtitle offers—is it a definition or a dare? The issue is organized neither chronologically nor typologically. It's not ethnographic or sentimental. Yet "Mothers & Daughters" relies on both of photography's elemental impulses: the desire to see others and the desire to memorialize. There are lines of poetry by Adrienne Rich, Anne Sexton, and Alice Walker. There are backyards, weddings, beaches, kitchens, embraces, American flags, sashes that read "Votes for Women," looks of impatience, and gazes for posterity.

Mark Steinmetz began taking pictures of his wife, the photographer Irina Rozovsky, and their daughter, Amelia, in 2017, when Amelia was an infant. While looking through "Mothers & Daughters," Steinmetz was thinking about the 1980s as a time when the domestic became a concern in photography: *Aperture*'s issue preceded the Museum of Modern Art's exhibition *The Pleasures and Terrors of Domestic Comfort* by four years. Among the portraits by Robert Adams, Judith Black, Jill Freedman, Rosalind Fox Solomon, and many others presented by *Aperture*, Steinmetz was drawn to a street picture by Garry Winogrand—the concluding note of the issue—of a woman walking outside a Doubleday bookshop on Fifth Avenue in New York, distracted yet propulsive, a small child on her back, a beaming daughter holding her hand. "I don't think I'm a nostalgic person," Steinmetz says of the photographs he made of Amelia's young life and the gestures of love between mother and daughter. "I got married, and we had a baby. So, I'm just photographing around me. It's inevitable. I also think my daughter is a star."

Page 85:
Amelia, Jersey City, NJ,
September, 2019;
this spread: *Sledding,
Commerce, GA,* January,
2022

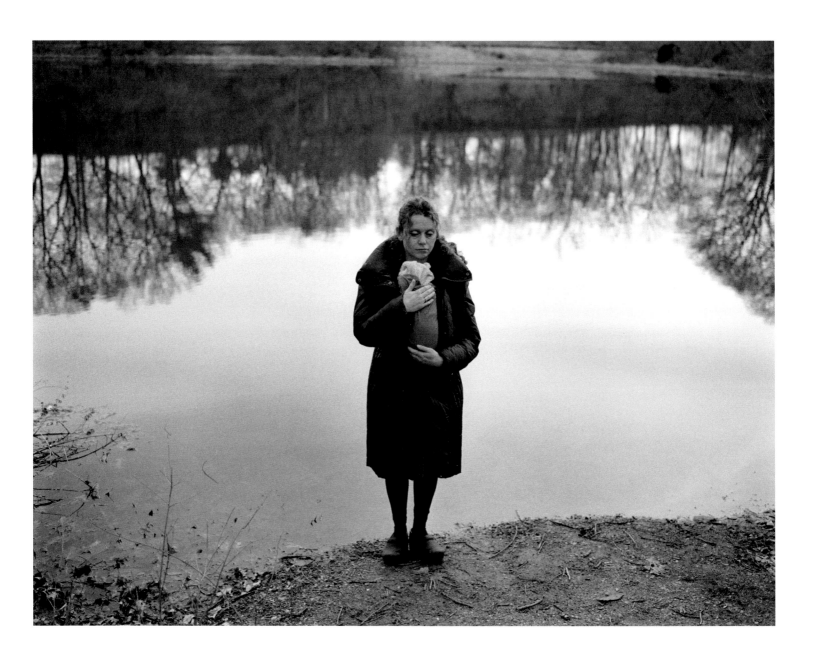

The Shape of Trans to Come

At the end of the millennium, photography was forming our understanding of life beyond boundaries of gender, time, and space.

Susan Stryker

Catherine Opie, *Angela Scheirl*, 1993
© the artist and courtesy Regen Projects and Lehmann Maupin

In *Aperture*'s fortieth anniversary issue, published in Fall 1992, there's a brand-new book advertised in the back pages—William J. Mitchell's *The Reconfigured Eye: Visual Truth in the Post-Photographic Era*. The marketing copy reads: "Enhanced? Or faked? Today the very idea of photographic veracity is being radically challenged by the emerging technology of digital image manipulation."

Mitchell's book heralded one of the most significant developments in the history of photography: the accelerating shift from analog to digital image formats that would, over the course of the 1990s and in anticipation of the post-truth dimensions of the present day, increasingly render reality as its simulacrum. This shift, Mitchell contends, has been as profound as that from painting to photography, in that digital images are produced through fundamentally different material processes than analog photographs. Whereas an analog image indexes light bouncing off a physical object by means of chemical changes in a photosensitive emulsion fixed in space on some tangible medium, the string of ones and zeros that code a digital image's pixels may have no physical point of reference at all. Because digital images can be entirely untethered from the world of physical objects, they enact a wholly different representational practice.

Photography in the '90s was rife with exercises in the shaping of our understanding of identity, memory, time, and space amid technological advances—not just digital imaging, but the burgeoning cyberculture of the Internet—that increasingly blurred the boundaries between the factual and artifactual, the virtual and the real, the actual and the imagined. It solicited (then required) us to live in its dematerialized, ungrounded space. If the *fin de millennium* decade of the '90s could be condensed to a single figure exemplifying this preoccupation, that figure could arguably

be called *transgender*: a one-word name for the cultural fantasy of identity unmoored from embodiment's physical substrate.

Transgender as a newfangled term for age-old practices of gender crossing catapulted into common parlance in 1992 with the publication of Leslie Feinberg's *Transgender Liberation: A Movement Whose Time Has Come*. Feinberg penned their manifesto in the heyday of the queer, feminist, punk-inspired, rage-fueled, guerila-style cultural production typified by artists such as David Wojnarowicz or the Gran Fury collective, which took aim at the ongoing necropolitics of the AIDS crisis. As Rita Felski noted back in the day in "Fin de siècle, Fin du sexe: Transsexuality, Postmodernism, and the Death of History" (1996), *transgender* came to stand in for any number of "premillennial tensions" and technocultural anxieties about the future of selfhood. By decade's end, a diffuse trans sensibility so saturated society that the film theorist Caél Keegan could claim, credibly, that the transgender aesthetic covertly informing Lana and Lilly Wachowski's first *Matrix* film, in 1999, was the secret sauce explaining how that work became the paradigmatic pop-cultural visual representation of digital-media environments. If trans-as-abstracted-from-physicality is what the post–Cold War New World Order increasingly *felt* like, for everyone, then *The Matrix* is what we imagined it *looked* like.

Aperture showed up late to this trans aesthetics party, and kind of hung around its edges without opening out to the deeper implications of what was at stake in decentering biological concepts of personhood. It capped its own *fin de millennium* with a Summer 1999 issue titled "Male/Female." While the cover featured a stunningly gender-fluid 1928 double self-portrait by Claude Cahun, and the guest editor Vince Aletti's cool catch of an interview with Madonna gave a drive-by nod to the megastar's genderqueer 1990 "Vogue" video, *Aperture*'s own editorial introduction pointedly reinscribed the gender binary that structured the issue: "Humankind's first and most essential dichotomy—that we are

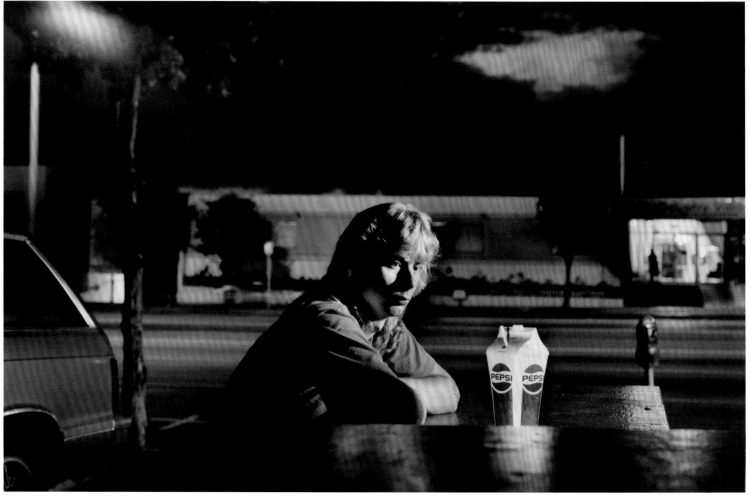

Elaine Reichek, *Red Delicious*, 1991, from *Aperture*, Fall 1992
Courtesy the Dallas Museum of Art

created in two natures, male and female—has fascinated artists for millennia."

Instances of trans representation can be found sprinkled in *Aperture*'s pages throughout the '90s—a Nan Goldin drag queen here, Peter Hujar's photograph of Greer Lankton's legs there, Robert Mapplethorpe's gender-bending physique pictorials of Lisa Lyons elsewhere. There was plenty of other work circulating in the '90s, in and beyond the pages of *Aperture*, that pushed gender visibility and performance in exciting directions: Loren Cameron's raw, unprecedented views of trans men, as well as more studied works by the likes of Catherine Opie in her *Being and Having* series (1991), Cindy Sherman's playful self-portraits, Philip-Lorca diCorcia in his *Hustlers* series (1990–92), Walter Pfeiffer and Collier Schorr's evocative photographs of feminine young men, and Inez & Vinoodh's fashion images. But while *Aperture* sometimes depicted transgender people or things, it never foregrounded transness as a more-than-gender aesthetic mode, one that infused digital culture at the end of the millennium with fantasies about escaping the material realm.

But even in that 1992 issue with the ad for Mitchell's *Reconfigured Eye*, published the same year as *Transgender Liberation*, there were glimmers in *Aperture*'s pages of precisely that sense of transness: something in excess of the figural, gesturing beyond familiar habits of perception that reproduce bodies in our imaginations in accustomed ways. The broken mirror of Barbara Kruger's *You Are Not Yourself* (1981) provides a good point of departure, showing us a world whose conditions of visual representation have been shattered. What is being trans if not the recognition that representation as it has been handed to you necessarily fails you?

Given the nonfigural, nonrepresentational dimensions of this emergent trans aesthetic, a photograph's paratexts—those

Spread from *Aperture*,
Summer 1999, with
photographs by Mariko
Mori, Cindy Sherman,
and Sandy Skoglund

There were glimmers in *Aperture*'s pages of that sense of transness: something in excess of the figural, gesturing beyond familiar habits of perception.

seemingly supplemental bits of verbiage, such as an artist statement, that contextualize the supposedly main attraction—can be as important as the visual work itself when they instruct audiences to see something otherwise visually imperceptible. The work by the multimedia artist Elaine Reichek titled *Red Delicious* (1991), published in *Aperture*'s Fall 1992 issue, has no discernible trans content, but her broader practice blends needlecraft with digital photography to translate the physicality of the stitch into the immateriality of the pixel in ways that resonate with the questions posed by transgender aesthetics in the '90s and after. *Red Delicious* depicts a colonial encounter between an Indigenous perspective and cultural constructs of family, gender, and personhood rooted in the biology-based Western sex/gender binary criticized by movements for "transgender liberation," but it's Reichek's comment on the image that most deeply drives home the connections to transness. Photography, she says, purports to observe what objectively exists, "when in fact [it] is part of an attitude, a cultural stance, a politics, an ideology, a whole mental structure of which the camera is only a small part . . . an iceberg with the photograph at its tip." A nonfigural trans aesthetic likewise attends to rendering perceptible, if not necessarily visible, the structures underpinning the mode of a body's appearing.

Michael L. Sand's essay on Arthur Batut's nineteenth-century photography, which concludes *Aperture*'s 1999 "Male/Female" issue, similarly exposes submerged racial ideologies. In the 1880s, Batut was a pioneer in the recently developed technique for producing composite portraits by superimposing images of multiple subjects over one another on the same plate; he aimed to see beyond the particularities of any individual face to capture the essence of ethnic physiognomies native to a given geographical location. As Sand notes, Batut's visual work anticipates the digital composites of artists such as Nancy Burson and Keith Cottingham, while the artist's own words about his aims in that work presciently foreshadow the abstracted-from-physicality aesthetics of the

Above: Mariko Mori, Mirage (E), 1997. Opposite, top: Cindy Sherman, Untitled #275, 1992. Opposite, bottom: Sandy Skoglund, At the Shore, 1994

80

Arthur Batut, *Fifty inhabitants of Labruguière and their composite "portrait-type,"* ca. 1885–86, from *Aperture*, Summer 1999

digital era: "To reproduce, with the aid of photography, a face whose material reality does not exist, an unreal being whose constituent elements are disseminated among a number of individuals and which could not be conceived except virtually, is this not a dream?"

Batut's project was inherently racialist, in that it sought to produce the visual ideal of a biological body shape. But something funny happened on the way to Batut's visualization of idealized racialist types—something evident in his *Fifty inhabitants of Labruguière and their composite "portrait-type"* (ca. 1885–86). As surely as Batut's technique selected for and reiterated a certain shape of whiteness, it merged the male and female forms of those French villagers into androgyny, resulting in a ghostly composite image that was simultaneously ethnically homogeneous and gender homogenized. In other words, he sought to sharply delineate a shape of race that was virtually present, only for it to come out looking like a gender blur.

That blurring of gender was a consequence of Batut's attempt to visualize an essence that transcended the particularities of any given flesh. At his fin de siècle as well as our recent *fin du millennium*, the manifestation of transness as an aesthetic potential pointing beyond the physical—whether in the abstraction of race or the shift from analog to digital media—finds its most fitting image in transgender figuration.

Susan Stryker is the author of *Transgender History: The Roots of Today's Revolution* (2017) and the founding coeditor of *TSQ: Transgender Studies Quarterly*.

John Edmonds

Father's Jewels

In the fall of 1990, as the "culture wars" reverberated throughout the art world, *Aperture* published an issue titled "The Body in Question." Reproductive rights, the AIDS crisis, shifting notions of gender, and the attack on the National Endowment for the Arts by conservative politicians were among the roll call of urgent concerns (many eerily echoed today) tackled across its pages. For the photographer John Edmonds, who is celebrated for his emotive, intimate studies of Black masculinity, this issue still resonates. "I thought a lot about 'The Body in Question,'" Edmonds says, "and had the idea of a group of individuals performing grief."

During a one-day production in New York, in an old building selected by Edmonds for its quality of feeling out of place and time, he cast a group of men he pictured as forming a family unit. Organizing them into a range of tableaux to explore how their bodies could be oriented within the camera's frame, he was curious as to what stories would emerge and what emotions might be conveyed. Edmonds's references run the gamut. He views the television series *The Sopranos* as critical to debates around violence in entertainment and pop culture of the 1990s. Connecting to his ongoing interest in African art, the photographs also feature an Igbo sculpture, 3-D printed for this project, that represents parental spirits; the men gather around totemic objects as if partaking in improvised religious rituals. While considering the matrix of censorship, art, and religion in the '90s, Edmonds recalled his own religious upbringing: "I was interested in art that was censored because it used religion as a framework to talk about the politics of the time. I was raised very religious, during the years when that censorship was happening. Religion is something many of us are traumatized by. I think it is a human right to use the things that have traumatized you to search for healing."

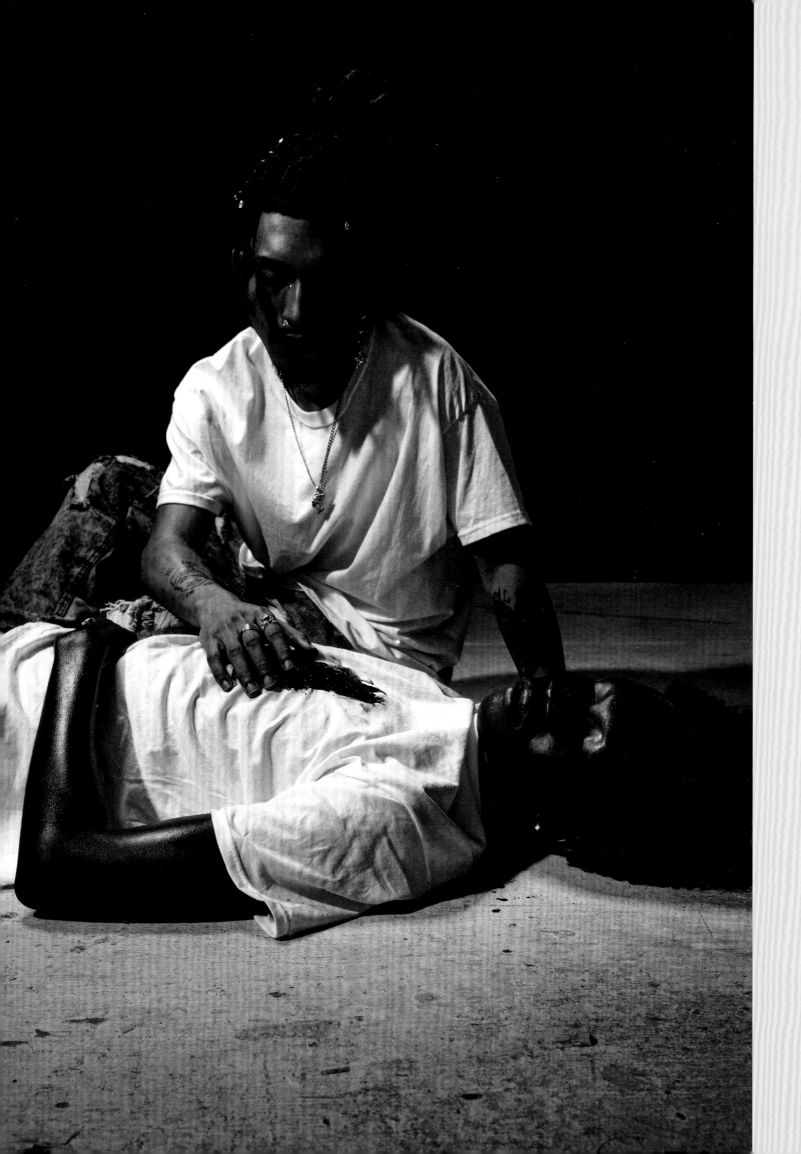

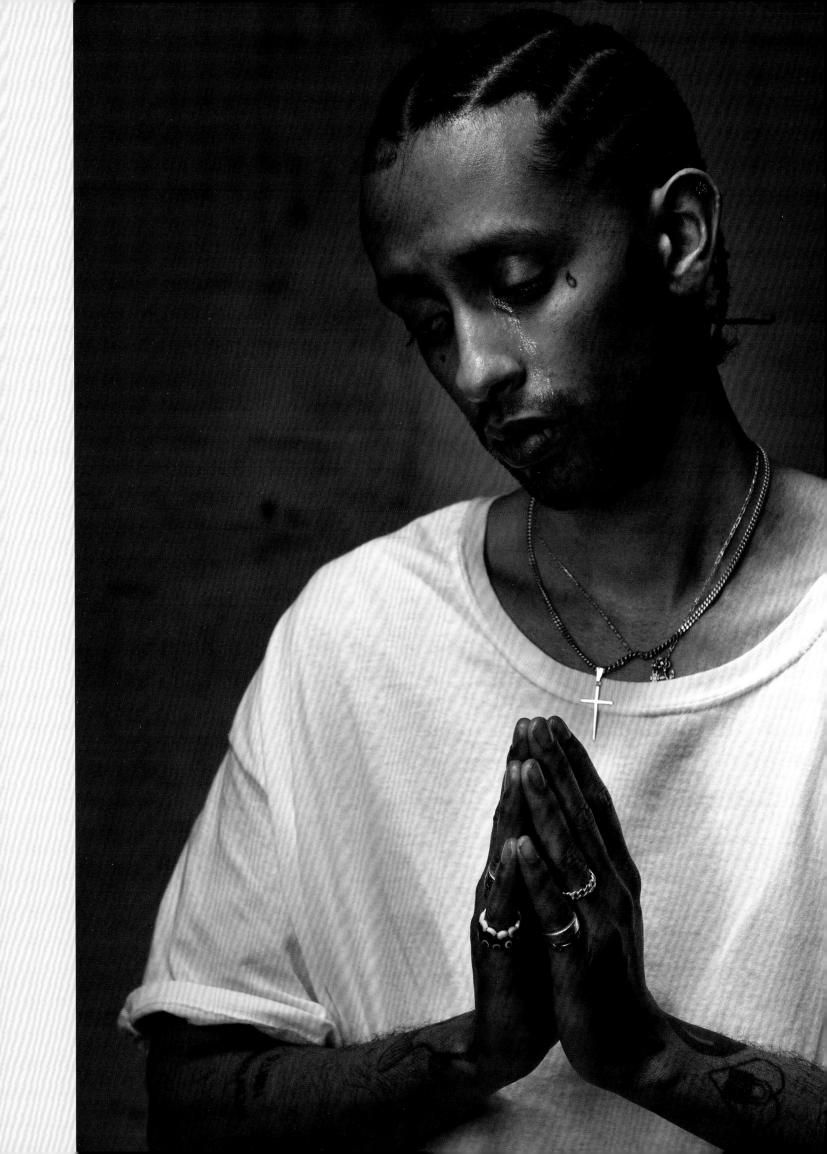

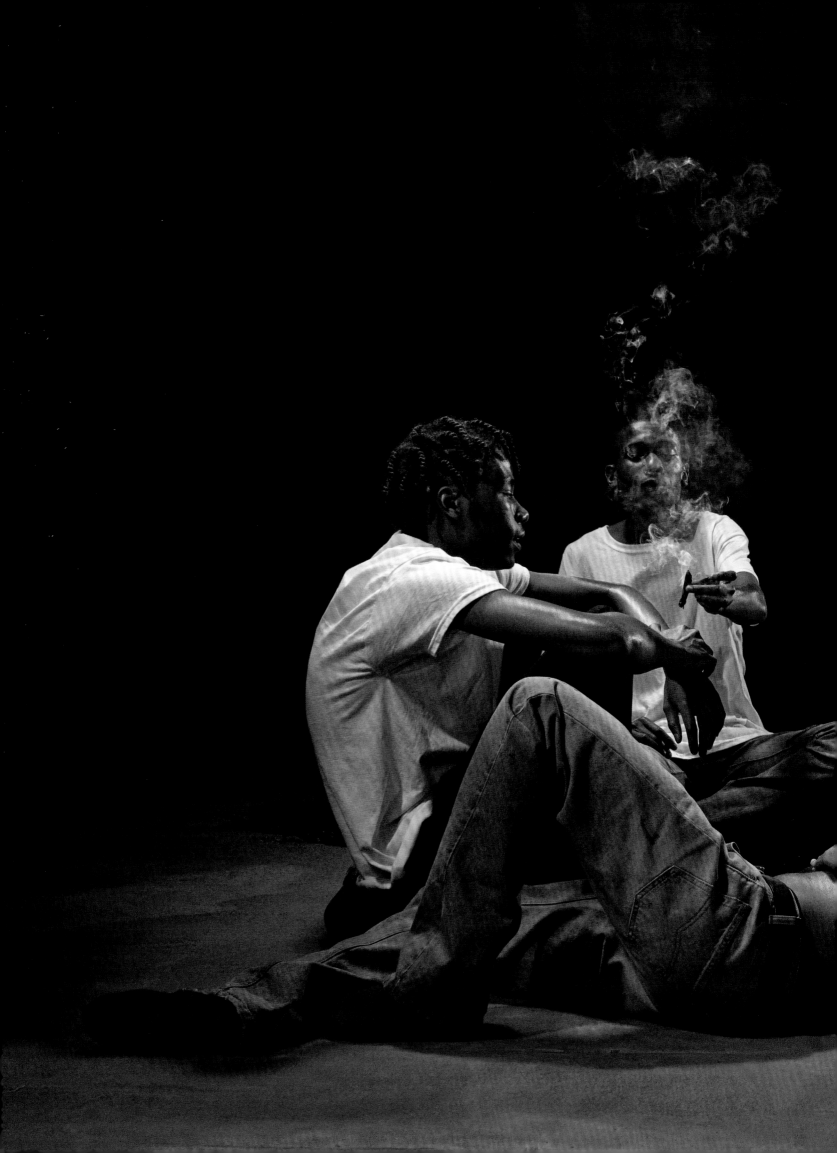

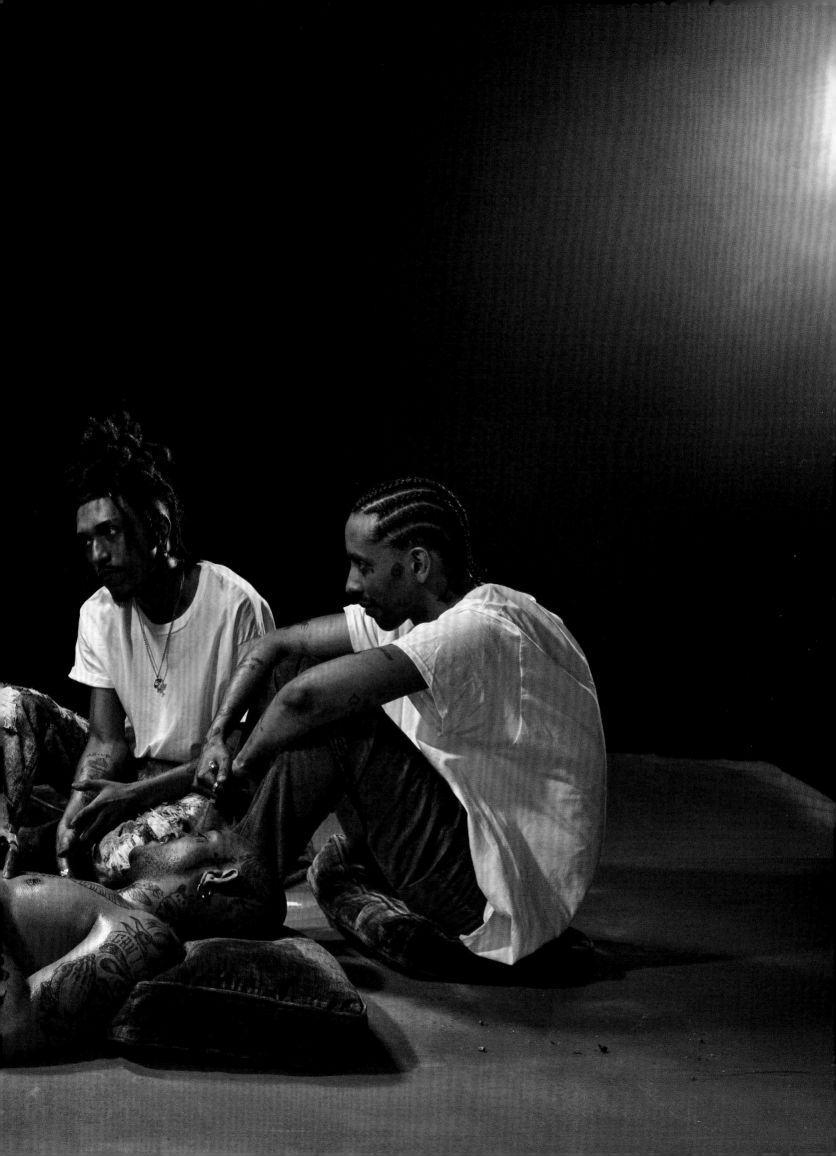

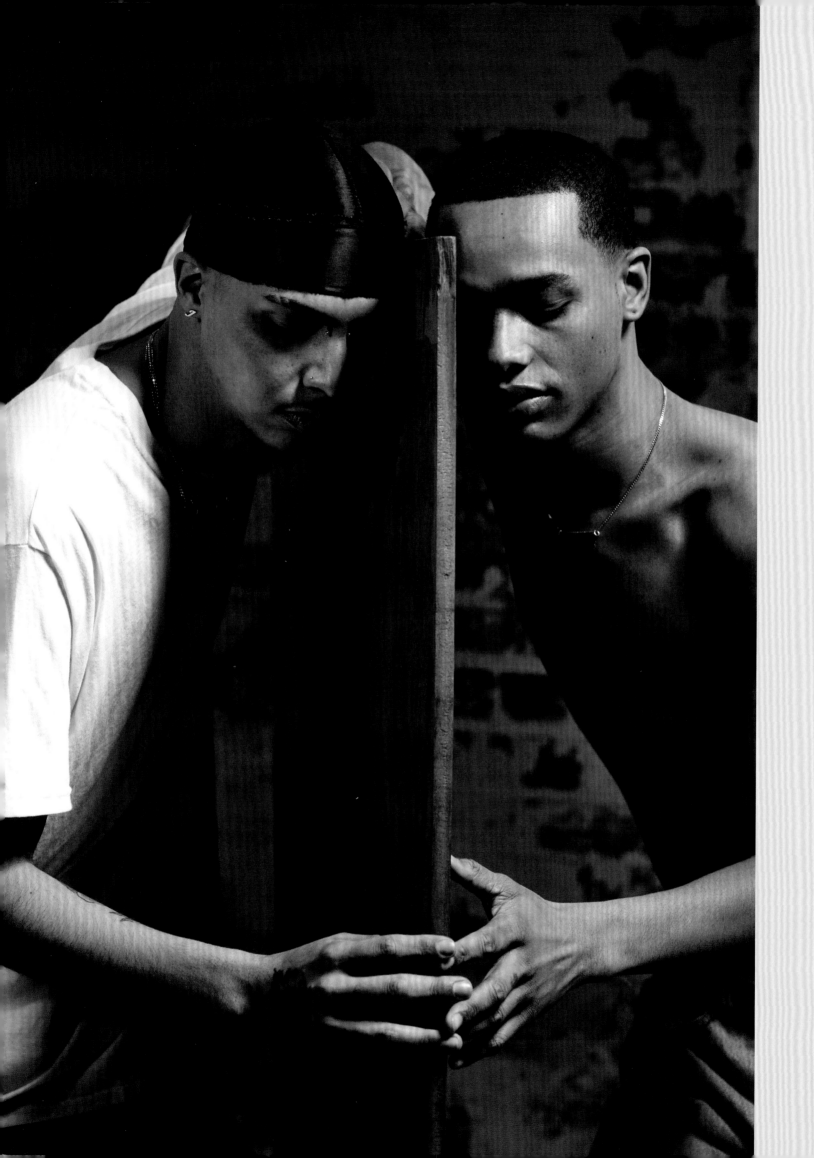

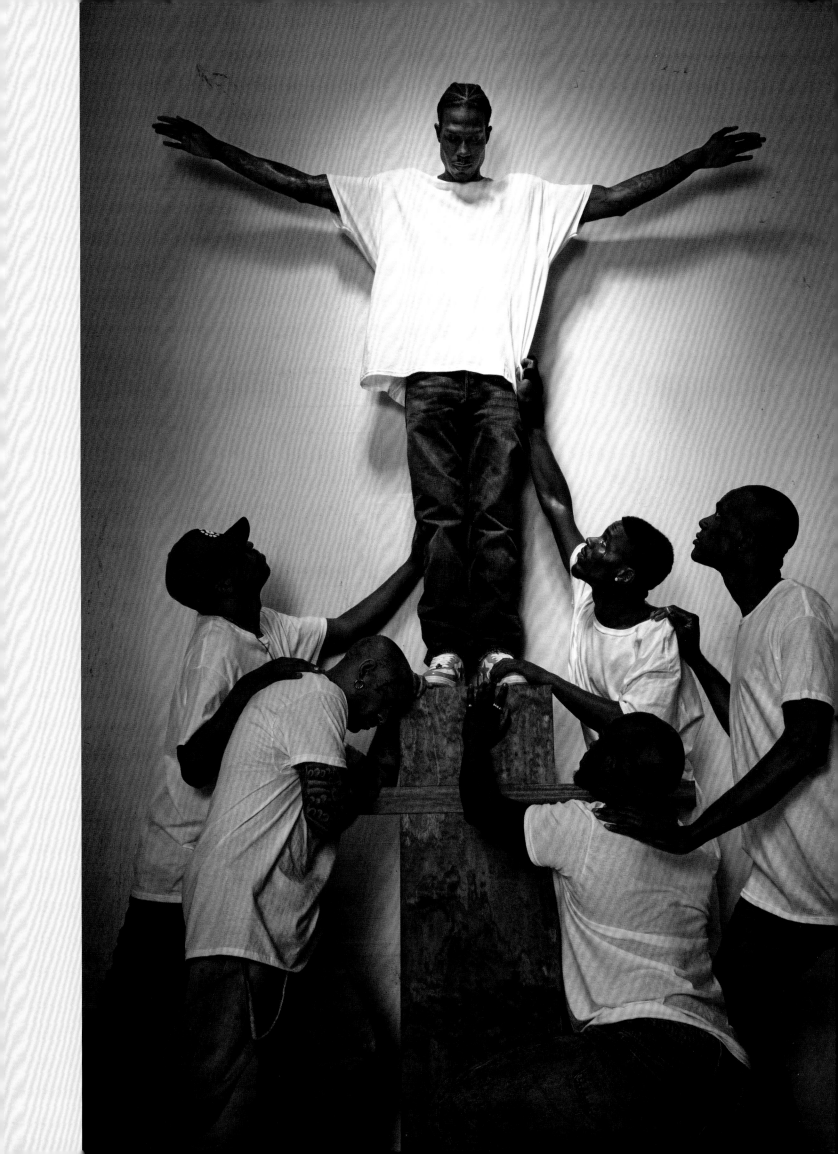

2000s

This page:
Trevor Paglen, *LACROSSE/
ONYX V Crossing the
Disk of the Moon (Radar
Imaging Reconnaissance
Satellite; USA 182)*, 2007
Courtesy the artist and Pace
Gallery, New York

Opposite:
James Welling, *#005*, 2005
© the artist and courtesy
David Zwirner

Real Life and Living Memory

In the first decade of the twenty-first century, photographers sought the tangible in an increasingly digital world.

Lynne Tillman

The twentieth century turned anxiously into the twenty-first—Y2K doomsday. Computers, it was feared, would all implode, and before 2000, feverish nations spent millions to avoid this catastrophe, which didn't happen, but a year into the century, it did—9/11. The Towers came down, so-called ordinary Americans randomly attacked Muslims, and George W. Bush, Dick Cheney, and Donald Rumsfeld launched a preemptive, disastrous war against Iraq, which had nothing to do with 9/11.

While 9/11's detritus blew in the wind, polluting lungs, the photography editor Alice Rose George and others curated a pop-up gallery in SoHo to display 9/11 pictures. Amateur and professional disaster photographs covered the walls. Easily taken, easily deleted, cell phone pictures were instant, and instantly blurred categories. In them, the decade found its avatar.

In 1991, cell phone technology evolved from analog to digital. Photoshop, released a year earlier, would prove subversive, by inciting ex post facto image remakes. Many artists embraced the software's possibilities, though some photographers resisted it. Their arguments emanated from a commitment to or belief in a photograph's inherent integrity. The original image was felt to have an essence, which should be spared manipulation. That same argument has also addressed digital art forms—that is, manipulation itself has been regarded as somewhat sinister.

Facebook launched in 2004, YouTube in 2005, Twitter in 2006, and Instagram in 2010, all still popular today but for

In every art form, the new, usually called an advance, bedevils the old and stirs up new doubts.

how much longer. Platforms and devices enter homes like new animal companions; but every obsolescence or death, unlike that of a pet's, is welcomed. Obsolescence will bring something better.

In the first decade of the twenty-first century, high-def TV replaced most broadcast analog TV, and digital photography took seed and flowered. Working digitally allowed invention during and after. And its seductive immediacy—no need to wait for an image to emerge in its cloudy chemical bath. Most obviously, photography was no longer a modernist endeavor, since light was not needed to develop an image. In addition, a photograph as an entity, as a thing, did not matter, and would not unless photographers made a photograph's ontology their focus. And many did. Digitalization is now studied as an aspect of post-postmodernism or meta-postmodernism. The bases of classical photography were shattered.

Already laboring under the proverbial glut of images, art photographers and artists were confronted by an exponential tsunami of them. In this decade, an ongoing debate was fomented: What is a photograph? What is its status now? Where is the field? (In those heady days, some artists whose work I describe here appeared in *Aperture*'s pages.)

Barbara Kruger, whose "words and pictures," as she describes her practice, keep changing the face of art, began by doing physical pasteups of found images, and now produces her art digitally across many media. Multiscreen videos are assembled on a computer; works sent as files will be manufactured as vast vinyl prints for specific sites, then installed on walls, floors, ceilings, and stairs. The words and pictures will be in perpetual motion, restless as the contemporary moment.

James Welling dove into digital explorations in the summer of 1998. His first series, *Tricolor*, a group of digital color ink-jet prints, was scanned from three black-and-white negatives. In 2000, the final images of his second group of *New Abstractions* (1998–2000) were produced digitally and printed on chromogenic paper. Welling keeps materiality, physical presence, alive, by engaging with photography's historical modes, its possibilities, along with its new technologies.

Zoe Leonard is probably best known for her massive ten-year project *Analogue* (1998–2009), which documents a vanishing New York, especially Lower Manhattan's storefront facades and displays. Her timeless project about a lost time also comments on the vanishing of analog photography. Leonard still works primarily with analog processes, but for a recent work, *In the Wake* (2016), she used an iPhone to shoot old family photographs. She says it was "not a replacement for analog but a different way of thinking and making work. . . . It was a way of working that was immediate and physical."

Leslie Hewitt's works in the series *Riffs on Real Time* (2002–9)— found images of families and those from popular culture—are composited visual narratives. Her art transgresses disciplinary boundaries, sometimes incorporating sculpture, further amplifying the piece's physical presence, like an installation. Hewitt's pictorial narratives breach time lines, representing family and history as layers of images, words, events, the collision of past and present.

LaToya Ruby Frazier's contemporary photographs of her family and neighborhoods under stress might seem taken in a different time. She photographs primarily with black-and-white film and typically uses three medium-format cameras. Frazier is close to her subjects—her friends and family—and aims for intimacy. In her prints, as in those of Roy DeCarava, Black skin and Blackness are tonally complex, like the individuals and scenes she portrays. The color black is never a background for something else.

Color is meant to show real life—real life is in color. In Frazier's photographs, real life is also in black and white and includes living memory. Stories and histories seem imprinted on faces and in

no one chooses their moment; and it will be natural to them. Aesthetic choices come down to what's available, to ideas, and to feeling, the way musicians feel their instruments. Sometimes it just feels better to photograph with one kind of camera; sometimes an artist adds an element, picks up a different device. But moralistic thinking about aesthetics and technologies appears inevitable.

Is it good for the world, for people? The invention of fire, was it good for people? In the artist Hito Steyerl's 2009 essay "In Defense of the Poor Image," she writes, "The poor image is a rag or a rip. . . . It transforms quality into accessibility, exhibition value into cult value." This thing, this tattered entity, holds something. It's called information, that is, the image isn't important, what it shows is, evidence maybe, a trace maybe. Degraded images have their place. Glossy or tawdry, well-made or desiccated, images circulate massively, and will only accumulate. Often I wonder what photographs are for, and why I look at them. A photograph is not a witness or a document, it's unreliable, it's a there, it's a not there, or there's no there there. Still, I seek something in it.

The first decade of the twenty-first century started with a national trauma turned global, and now everyone says these are transitional times, into what no one knows. Intimations are here. Drastic events—COVID, Ukraine, climate—carry consequences beyond what we can discern. There will be, and is, denial. Inexplicable and unforeseeable events will produce new conditions, technologies, experiences, and incite new art. The bases for judgment and criticism will undergo upheaval, also; standards will, necessarily, have to change.

In the 1930s, Bertolt Brecht wrote plays to instruct his audience about their true condition, reality as it was. His assumption: he knew what reality was, and he knew it better than his audience did. Maybe he did understand the political situation better than most, but it's a perilous position. I can't think of a contemporary self-conscious artist who would think that now. I would hope not.

Lynne Tillman is a novelist and cultural critic. Her most recent book is *Mothercare: On Obligation, Love, Death, and Ambivalence* (2022).

Hannah Whitaker

Millennium Pictures

The language of technological innovation is tinged with anxiety and awe. Its vision recasts us as beneficiaries of a more connected humanity—somehow both more human and more than human—yet its promise often feels suspect. In a review of William A. Ewing's 2004 exhibition *About Face*, which proclaimed the death of the photographic portrait, Vince Aletti writes in the pages of *Aperture*'s Winter 2004 issue: "Even before photography's documentary credibility was deliberately and irrevocably eroded from within, pictures of our fellow humans had been stripped of virtually all pretense to revelation, insight, or any but the most superficial emotional content."

This skepticism frames Hannah Whitaker's silhouetted portraits and still lifes, which address an unease, pervasive in the twenty-first century, about how technology relates to our humanity.

Seemingly familiar human figures are obscured and manipulated into dark, synthetic forms. "I wanted to make photographs that center around a particular face, without actually depicting it," Whitaker states. Using mirrors, long exposures, reflective materials, special lighting, and anthropomorphized arrangements, her work treats technology as a medium as well as an aesthetic position. Many images employ digital interventions to conceal, dislocate, or duplicate human appendages, a response to technology's tendency to fragment our everyday experiences and evacuate meaning in the service of data. In their stark contrasts, these "portraits" carry a menacing subtext within their outlines and an all-too-human trepidation in the face of disorienting change—a feeling as relevant today as it was decades ago.

Everyday People

In a time of overabundant information, could the photo-album hold cultures together?

Salamishah Tillet

Last May, my children discovered my photo-album from college. As they laughed at images of me in my early twenties wearing big twist outs and patterned head wraps, or of their dad with his tight fade and tighter shirts, I realized how unfamiliar to them this intimate object of mine was. For me, each plastic-covered page revealed one or more carefully curated stories from my young adulthood. In contrast, my daughter, who was born in 2012, and my son, born in 2015, saw the album quite differently. For them, it was a random assortment of images and an artifact that offered a glimpse into their parents' yesteryear.

But that experience was also a rite of passage. As they visited my early adulthood, I flashbacked to my own poring over of my parents' albums when I was a child in the 1980s. Unbeknownst to me at that time, I was, in fact, participating in an intergenerational ritual that I would later share with my own children: the impromptu celebration of the family archive.

In many ways, my children's curiosity was part of a larger trend. While the physical photo-album itself seems to have been replaced

with Instagram feeds or camera phone folders, it has simultaneously been repurposed. Now, it is less a method to freeze time and more a muse for artists in their own contemporary practices. I imagine this turn is, in part, an intervention into the rise of the selfie as a primary means of personal expression and social-media influence in the 2010s. Lest we forget: Kim Kardashian's photobook, *Selfish*, featuring countless selfies of Kardashian traveling, with her family, and in swimsuits, was a *New York Times* bestseller in 2015.

Whereas the selfie emerged in the last decade as our ultimate symbol in an era of instant access and casual self-importance, the picture album, as a series of either snapshots or collective self-portraits, suddenly felt far humbler and more intimate. Though the Russian Ghanaian photographer Liz Johnson Artur has been documenting the everyday lives of Black immigrants in London, Brooklyn, Kingston, and Accra for more than three decades, the album was the conceit she used when she chose to connect these images together in *The Black Balloon Archive*, on ongoing series that she began in 1991. Described by Ekow Eshun in the Winter 2018 *Aperture* as "a family album for the diaspora," this format enabled Johnson Artur to capture multiple people, periods, and places. Seeing her subjects as "my neighbors," she visualizes the feeling of Black belonging, offering them a home space in which each can gather together, as Eshun notes, "on one's own terms."

Such inclusion was not always guaranteed. In its earliest conception, the family album indicated the wealthy economic status and high social standing of the Victorian-era elite in the 1850s. A hundred years later, photo technology had advanced so much that the baby-boomer generation saw photographs as indispensable. But in today's world, "What does that same device have to offer the contemporary artist?" as artist Carmen Winant asked in "Into the Album," her essay that also appeared in the Winter 2018 issue. "In what ways can the family photo-album behave as a kind of confirmation—or assertion—of our very survival, dignity, and existence?"

As a contemporary artist herself, Winant ended up turning to Glenn Ligon's much earlier queering of the family album in *A Feast of Scraps* (1994–98) and Lorraine O'Grady's disrupting of linearity in her *Miscegenated Family Album* (1980/1994) as both radical reclamations of the genre as well as inspirations for Winant's own feminist practice. Likewise, Jack Halberstam reminds us of the family album as a counter-archive. In his Winter 2017 *Aperture* essay, "Eric's Ego Trip," he writes about the powerful gift that Reed Erickson, a wealthy, white trans man known for his philanthropy, gave to the ONE National Gay & Lesbian Archives, in Los Angeles.

I find optimism in the desire among contemporary artists and scholars to resurrect this family genre. Their considerations of these older photo-albums are not overly sentimental or nostalgic. Instead, they turn to this earlier format to better reflect our ever-expansive notions of gender, race, sexuality, and belonging, and to reject those racially homogenous and heteronormative notions of the American family that continue to thwart us as a nation.

And yet, the 2010s were also the decade of the spectacular. In addition to selfies, there was no shortage of random, often viral, images for us to click, like, or upload. At the same time, such distractions did nothing to ease the grief, and rage, that we felt as we watched unarmed Black people being killed by the police online or played on a twenty-four-hour loop.

In this "information overabundance," as Fred Ritchin lamented on these pages in the winter of 2012, such excess made it difficult for us "to focus on any one image, or set of images." In other words, the proliferation of photos and video content ended up minimizing the power of a single picture and its ability to foment activism akin to that of the civil rights and the antiwar movements of the 1960s. Instead, the oversaturation compromised "the credibility and

Artists turn to this earlier format to better reflect our ever-expansive notions of gender, race, sexuality, and belonging.

authenticity of photographs that purport to frame the real," he wrote. In such an age, only the viral video, like the one heroically filmed by seventeen-year-old Darnella Frazier of George Floyd's murder, has inspired mass protest.

But rather than compete with spectacle and surplus, contemporary photographers have revived an even earlier form—the portrait—to enact everyday protest. Across *Aperture* issues from this decade, the ordinary is the alternative to oversaturation.

The large-scale portrait is the medium of choice for Farah Al Qasimi, a photographer and native of the United Arab Emirates. Her bright, color-saturated images of people at beauty salons, shopping malls, and traditional pharmacies in her home country have become her signature style and were exhibited in 2020 on one hundred New York bus shelters. "Her Instagram feed is a

Farah Al Qasimi, *Arun (Rose Studios Satwa)*, 2014, from *Aperture*, Winter 2016
Courtesy the artist

glorious mix of high art and everyday image inundation," Kaelen Wilson-Goldie wrote of her work in the magazine's Winter 2016 issue, "On Feminism." "And between them, the boundaries are blurred."

This dissolution between the real and the staged is also a defining trait of four very different artists—Kimowan Metchewais, Zanele Muholi, Buck Ellison, and Tyler Mitchell—whose portraits are revelatory. Though Cree artist Metchewais passed away in 2011, *Aperture*'s more recent reprisals of his work affirm the power of the small photograph self-portrait to upend longstanding racial stereotypes. His specific use of Polaroid portraits not only afforded him a malleable medium to dissect, rearrange, and then display on large-scale paper but also gave him a "visual sovereignty" that contested the willful erasure of and violence against Indigenous communities by the State. Muholi's *Brave Beauties* (2014), on the other hand, is a series of portraits about Black trans women in South Africa that calls attention to the way in which Black queer or lesbian South Africans are vulnerable to gender-based violence. "Today, lesbians in South Africa are brutally murdered," Muholi told Deborah Willis for *Aperture*'s Spring 2015 issue, "Queer." "'Curative rape' is used on us. That forces me to redefine what visual activism is." Muholi adds, "Art needs to be political—or let me say that my art is political. It's not for show. It's not for play."

In contrast, Ellison uses models to re-create those intimate moments among the white elite in which racial and class hierarchies

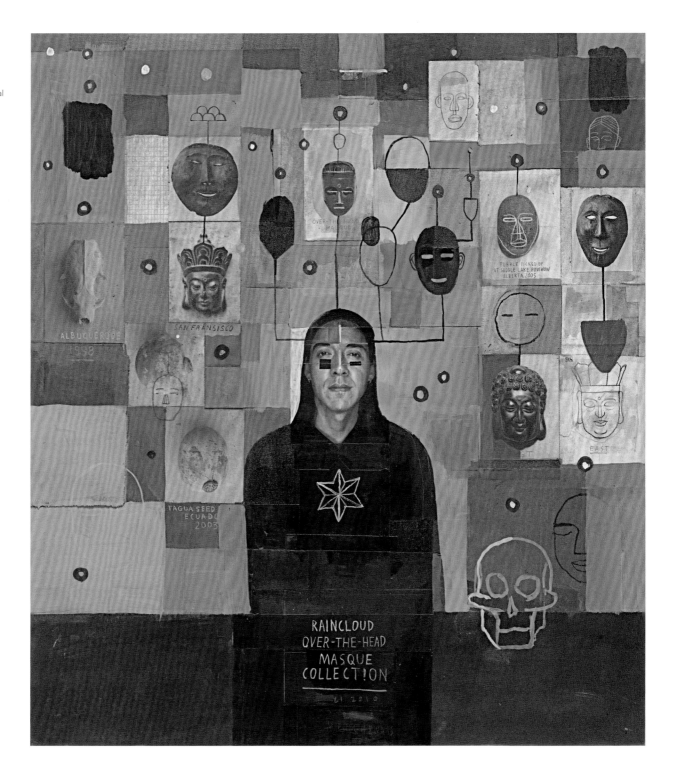

Kimonwan Metchewais,
Raincloud, **2010, from**
Aperture, **Fall 2020**
Courtesy the Kimowan
[McLain] Metchewais
Collection, NMAI. National
Museum of the American
Indian Archives Center,
Smithsonian Institution

are reinscribed. And by giving us access to the inner worlds of such white privilege, Ellison reveals and gravely reminds us how power is informally yet consistently wielded, even in the prosaic space of a dressing room or family driveway.

And in the decade-ending "Utopia" issue, I had the good fortune of exploring how Mitchell's aesthetic flips white privilege on its head. He lingers in the imaginative possibilities of Blackness, often capturing his friends and fashion icons from throughout the African diaspora in relaxed settings and in nature. "Inherent to photography, especially when you think of it historically, is a strong hierarchy, where the photographer is the one with all the power, the one who is seeing," he told me. "And the person being seen has almost no power. So, for me personally as a photographer, I ask myself, 'What are the things I can do to lessen these inherent hierarchies in the photography-shoot structure of seeing and being seen?'" In his oeuvre, the wide-scale portraits become landscapes in which Black people find a haven, and the ability to rest is rendered as justice.

As for my children, they are now obsessed with the technologies of their age. TikTok, Zoom backgrounds, and iPad screenshots are their preferred forms of self-expression. As I struggle to find a way to store those images, I have begun to print out a select few from my phone and put them in our brand-new photo-albums as a way of safeguarding our memories for the future.

Salamishah Tillet is a contributing critic at large for the *New York Times.* She was awarded the Pulitzer Prize for Criticism in 2022.

Hank Willis Thomas

Quilts

Kwame Brathwaite, the Harlem photographer who helped popularize the clarion slogan "Black is beautiful," was known as the "Keeper of the Images." His pictures of Black models and musicians from the 1960s are essential documents that radiated from New York during an era of Black and African independence campaigns. Although known to scholars and archivists, Brathwaite's work didn't reach a wider audience until *Aperture*'s 2017 "Elements of Style" issue. As an elder statesman of the Black freedom movement, Brathwaite became the "keeper of the stories, too," Tanisha C. Ford wrote. "If he didn't share this history, it would be lost to time."

The artist Hank Willis Thomas is also a keeper of the images. "Sometimes I see myself as a visual-culture archaeologist or DJ," he explains. "All of my work is about framing and context." In this series of collages, which reference traditional quilt patterning, Thomas draws on stories from *Aperture* in the 2010s, a decade during which looking back was as vital as looking forward. He sets in kaleidoscopic motion an energetic range of associations and styles: Joel Meyerowitz's stately portraits from Provincetown in the era before AIDS and Nick Sethi's dizzying chronicle of a festival for a transgender community in India; Renée Cox's self-portraits about power and Dave Swindells's endless nights on London's dance floors. Revivifying history, remixing the present. Thomas sees these collages as a collaboration with peers and mentors he's long admired. "The process of weaving these images has been revelatory," he says. "Through this blending, I was able to engage more intimately with the images, the subject matter, and the journey of the image maker."

Kwame Brathwaite: Black Is Beautiful

Wendy Ewald & Eric Gottesman: We're Talking About Life and Culture

Dave Swindells: Taking pictures definitely kept me going

Joel Meyerowitz: On the Beach

Nick Sethi: The Third Gender

Robert Voit: New Trees

Renée Cox: A Taste of Power

PHOTOGRAPHY

125th Street
Photography in Harlem
Edited by Antonella Pelizzari and Arden Sherman
Cloth $35.00

From
HIRMER
PUBLISHERS

Made Realities
Photographs by Demand, diCorcia, Gursky and Wall
Edited by Draiflessen Collection
With Contributions by Julia Franck, Jonas Lüscher, Angela Steidele, and George Pavlopoulos
Cloth $35.00

Pavel Odvody
Photography
Edited by Claus K. Netuschil
With Contributions by Julia Hichi and Celina Lunsford
Cloth $40.00

From
Scheidegger & Spiess
Art I Photography I Architecture

Aenne Biermann
Up Close and Personal
Edited by Raz Samira
Paper $50.00

Distributed by the
University of Chicago Press
www.press.uchicago.edu

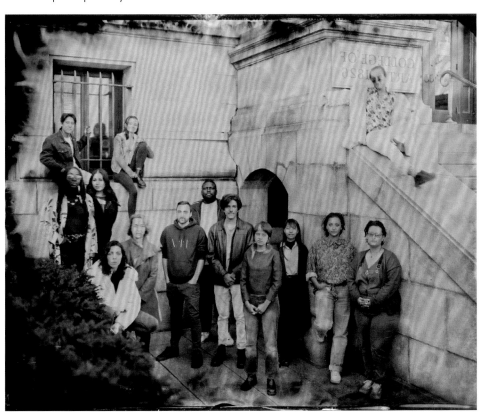